LICHFIELD

A POTTED HISTORY

TERESA GILMORE

AMBERLEY

To J.E.F, L.E.F and N.C.F.

Acknowledgements

The Visit Lichfield tour guide team (current and past): Lisa Clemson, Aileen Beesley, Emily Waldron, Julie Moulds, Les Young, Robin Taylor, Suzanne Lloyd, David Titley, Peter Carrington-Porter and Sarah Dale. Your help, proofreading, support and knowledge over the years has been invaluable. John Mayne, Lichfield Cathedral School, for allowing access to photograph the north-east turret within school grounds. Clare Mills, the Tudor of Lichfield, for allowing access to photograph the priest hole and prison shackles. Andrew Kerr, Lichfield District Council, for providing the Foreword. Claire Middleton for proofreading. Friends who have helped either with proofreading or sourcing images: Helen Glenn, Greg Robson, Jason Fazakerley, Chris Clarke, David Titley, Ayesha Hussain, David Rowan, Julie Moulds.

The author and publisher would like to thank the following people/organisations for permission to use copyright material in this book: The Library of Birmingham, Lichfield District Council, the British Library, the Portable Antiquities Scheme, Birmingham Museums Trust, Ordnance Survey, the Turnpike Trust, the Syndics of Cambridge University Library, the Lichfield St Mary's Photographic Collection, National Gallery of Art, the Trustees of the British Museum and David Rowan.

Unless otherwise specified, photographs have been taken by the author and retain her copyright. Every attempt has been made to seek permission for copyright material used in this book. However, if we have inadvertently used copyright material without permission/acknowledgement, we apologise and we will make the necessary correction at the first opportunity.

First published 2024

Amberley Publishing
The Hill, Stroud
Gloucestershire, GL5 4EP

www.amberley-books.com

Copyright © Teresa Gilmore, 2024

The right of Teresa Gilmore to be identified as the Author of this work has been asserted in accordance with the Copyrights, Designs and Patents Act 1988.

ISBN 978 1 3981 0640 6 (print)
ISBN 978 1 3981 0641 3 (ebook)

British Library Cataloguing in Publication Data.
A catalogue record for this book is available from the British Library.

Typesetting by SJmagic DESIGN SERVICES, India.
Printed in Great Britain.

Contents

Foreword 4

Introduction 6

1 Sha'dow 9

2 Wall 16

3 Ho'ly 22

4 Cathe'dral 30

5 Reforma'tion 43

6 Rebe'llion 51

7 Enli'ghten 65

8 Mecha'nical Mecha'nick 76

 Appendix: Bishops of Lichfield and Coventry 88

 Further Reading 96

Foreword

Lichfield is growing. At the time of writing there are several major housing developments at various stages of construction on the edges of the city, delivering thousands of new homes. That the city is attractive as a place to live geographically is beyond question. Its proximity to Birmingham, central location, good transport links by road and rail make it so. But there are many places that can boast the same.

Lichfield is blessed with charm and is exceptionally beautiful in parts with an interesting history, and I like to think these attributes seal it for many people who choose to reside here.

There are numerous books detailing the city's past. This 'potted history' is a delight because it is exactly that: a brief yet satisfying summary of the city's history until 1900.

From the origin of the city's name to its establishment as an ecclesiastical centre, from the Roman occupation of nearby Wall to the story of the city's famous cathedral, there is a wealth of information, presented succinctly for the reader to enjoy.

Despite living in the city for most of my life there is much I did not know. The account of the layout of the streets is fascinating – much of the footprint remains unaltered to this day – and given Lichfield's status as the centre of the diocese, there is detail surrounding development of the cathedral and The Close.

Over the centuries Lichfield has been considered a pleasant place to visit not least by royalty.

Indeed, I had no idea that in 1347 Edward III and his court chose the city as the location to celebrate England's victory over the French at the Battle of Crecy the previous year. The party lasted for a week with jousting tournaments on what is now Beacon Park and evening feasts!

During the reign of Mary I three people were burnt at the stake for refusing to give up their Protestantism. Then when religious persecution was switched to Catholics during the reign of Elizabeth I, Catholics took to hiding in 'priest holes'. I was surprised to learn that one still exists on the top floor of the Tudor of Lichfield coffee shop and restaurant in Bore Street, concealed behind a chimney breast.

From the time of the Civil War through the eighteenth century when the city prospered as a coaching city and the Staffordshire Regiment was founded in the King's Head public house, Lichfield continued to play a significant part in English history and was also the base for a group of learned scientists and philosophers which included Erasmus Darwin, grandfather of the renowned Charles.

As well as highlighting Lichfield's development over the centuries there is a wealth of fascinating facts within this book. For example, I knew that the city had a brewery in the

nineteenth century but did not know that it became the biggest industry here rivalling Burton-upon-Trent.

This 'potted history' is well researched and whether you are a new arrival in Lichfield or not, it is an excellent summary of one of the loveliest and most interesting places in the Midlands.

Andrew Kerr, Lichfield District Council

Introduction

This book covers the city of Lichfield. Key places of interest have been numbered on the map. Sites and events from the larger parish and diocese of Lichfield are mentioned where they have a direct impact on the city of Lichfield. Chapter titles are taken from entries in Samuel Johnson's dictionary. This book is not an in-depth historical guide to the city of Lichfield but will provide a good overview of what happened, when, and how it shaped the place we know today, up until around 1900.

Archaeological artefacts found by metal detectorists and recorded by the Portable Antiquities Scheme have been used for the earlier centuries where documentary evidence is minimal. These are identified by a reference number, like LICH-123456. More details on these finds can be found by searching the online database available at www.finds.org.uk/database and entering the reference number.

Lichfield, one of the smaller British cities with a population of over 100,000, is situated north of Birmingham, in the county of Staffordshire. It has two mainline train stations (Lichfield City and Lichfield Trent Valley), with links to both the north and south. By road, the A5 or Watling Street is the main road nearby, providing links down to London and up to Holyhead in Wales.

The geology beneath Lichfield consists of upper Triassic sand, sandstones and quartzites. Glacial drift deposits sit above these, and they vary in depth between 2 metres and 10 metres, with a maximum depth of 30 metres. It is located within a small valley. Three water sources flow into the valley: Trunkfield Brook, Leamonsley Brook and Curborough Brook. The Curborough Brook is formed when both the Trunkfield and Leamonsley Brooks meet and join. The Curborough Brook feeds into the River Trent. Natural springs are also present, such as St Chad's Well. These water sources have played a crucial part in the development of the city and creating its current landscape.

Popular myth has the origin of the name Lichfield coming from 'Lych' as meaning 'dead' and field, therefore translated as the 'field of the dead'. Local legend states that there were 100 martyred Christians, buried at Christian fields during the third century. No evidence such as large communal burial pits have been found however. Etymological analysis of the name is more consistent with the origin being a mixture of Celtic 'Lyccid', Old Welsh 'Luitcoyt' and the Old English 'feld', roughly translated as 'Shadow of the Greywood'. This 'Greywood' was the forest of Cannock Chase, which until the eighteenth to nineteenth centuries extended up to the city boundaries.

The first diocese was that of Mercia and was founded in 656 by Diuma. When Chad was made Bishop of Mercia in 669, he centred the bishopric at Lichfield, and it was known as the Lichfield Diocese. The bishop's seat briefly moved to Chester in 1075 but from 1102 it was relocated to Coventry. From then onwards it was the Bishop of Coventry and Lichfield, with two seats, Coventry and Lichfield. The joint bishopric continued up

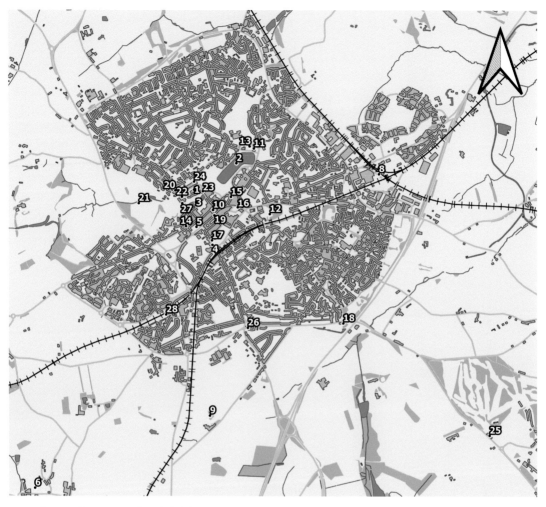

The Modern City of Lichfield. Key: 1 = The Cathedral; 2 = Stowe Pool; 3 = Minster Pool; 4 = the Hospital of St John the Baptist Without the Barrs; 5 = Franciscan Friary; 6 = Letocetum (Wall); 7 = City Station; 8 = Trent Valley Station; 9 = Knowle Hill; 10 = St Mary's Church; 11 = St Chad's Church; 12 = St Michael's Church; 13 = St Chad's Well; 14 = Sandford Street bar; 15 = Stowe Street bar; 16 = Tamworth Street bar; 17 = Culstubbe bar; 18 = Hospital of St Leonard; 19 = Guildhall; 20 = Milley's Hospital; 21 = Beacon Park; 22 = west gate of the Close; 23 = south gate of the Close; 24 = Bishop's Palace; 25 = Racecourse; 26 = Gallows; 27 = Free Library and Museum; 28 = Sandfields Pumping Station. (Map Copyright of Ordnance Survey)

until 1539, when Coventry Cathedral was dissolved and then it became the Bishop of Lichfield and Coventry. In 1839, the Archdeaconry of Coventry was transferred over to the Worcester bishopric, leaving Lichfield as its own diocese. A list of the Bishops of Lichfield has been included as an appendix.

The city was managed by the Bishop of Lichfield until 1548, when a charter granted secular authority to local bailiffs. A second charter in 1553 granted a sheriff and made Lichfield a city and a county. This stayed in force until 1888. The independence of the

Cathedral Close was confirmed by a charter in 1623, as it had been given self-governing status in 1441 and extended the privileges of the dean and chapter. Further charters were issued in 1664 and 1686, after which the city's government stayed the same until 1835, with the Municipal Corporations Act. This established a corporation of eighteen councillors under a mayor. In 1974, the self-governing status was lost, and it was absorbed into Lichfield District Council.

Nowadays, the City Council is run by a leader appointed by twenty-eight members elected from the nine wards (Boley Park, Burton Old Road West, Chadsmead, Curborough, Garrick Road, Leamonsley, St John's, Pentire Road and Stowe). A sheriff and a mayor are elected.

Street names have changed over time, reflecting changes in their use. Bird Street has been Newbrugge Street, Brigge Street and Byrd Street before sticking with Bird Street in 1669. Bore Street was Bord Street, Bore Street, and Boar Street by 1707, before changing back to the current spelling by 1800. Beacon Street was Bacoune, Baccunne, Bacone and Bacon, the latter still in use until 1836. Market Street was formerly Robe, then Sadler Street before sticking with the current name from 1766. Breadmarket Street was Wommones Chepying, then Wommens Cheaping until 1781.

I

Sha'dow

SHA'DOW n.s. [scadu, Saxon; schaduwe, Dutch.]
3. Shelter made by any thing that intercepts the light, heat, or influence of the air.
Here father, take the shadow of this tree
For your good host.
Shakesp. K. Lear.

Evidence for prehistoric activity within Lichfield is minimal due to the area being under almost continuous occupation since the eighth century and there being minimal redevelopment of the city area since the twentieth century. Most early evidence has been removed by the construction of medieval buildings and cellars, but stray archaeological finds demonstrate that people were living in this location.

The Stone Ages are the earliest periods in human history, and they are split into three phases: the Palaeolithic (Old Stone Age), Mesolithic (Middle Stone Age) and Neolithic (New Stone Age).

The Palaeolithic is the longest archaeological period, covering around 95 percent of chronological time. It spans from approximately 900,000 to 11,000 years ago. During this period, a land bridge to the European continent meant that Britain alternated being an island and a peninsula, as sea levels changed during the Ice Ages. Britain only became fully detached from continental Europe 10,000 years ago.

The Palaeolithic is split into three main periods: Lower, Middle and Upper. Arrival of modern humans (*Homo sapiens*) marks the start of the Upper Palaeolithic period, around 40,000 years ago. Other hominid species are associated with the Lower and Middle Palaeolithic. As people lived a nomadic lifestyle, evidence for human activity is scarce. It is only visible through stone tool finds, and butchery marks on fossil animal bones. Organic materials such as leather, wood and antler would have been used, but survival of these is incredibly rare. The landscape would have been mostly wooded, with occasional clearings.

Stray finds do turn up, like quartzite hand axes. Lichfield is not in a natural flint area, so the prehistoric inhabitants used local material, like quartzite, to make tools to hunt with. Quartzite can be worked like flint, but it does not fracture as reliably as flint, nor can it hold a sharp edge as long nor be as easily reworked. The main tool types are hand axes, choppers and cores.

After the Palaeolithic is the Mesolithic, from *c.* 10,000 BC to *c.* 4,000 BC, and is characterised by tiny worked flints, known as microliths, often fashioned into specialised tools such as spears. As ice sheets retreated, the landscape changed from arctic tundra style towards closed deciduous woodland. As the climate changed, specialised tools like harpoons and saws were invented.

Left: Thor's Cave, in the Manifold Valley, Staffordshire Moorlands, was a shelter for Palaeolithic nomadic dwellers.

Below: A Lower to Middle Palaeolithic quartzite hand axe (WMID-2D3554) found near Tamworth. (Copyright: Birmingham Museums Trust)

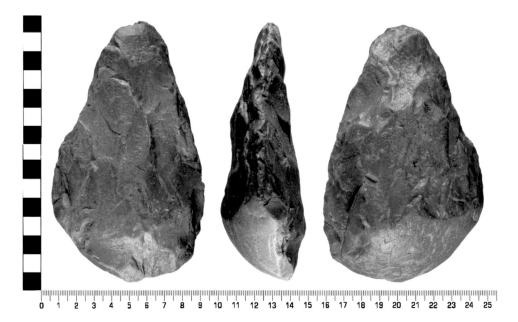

In 1978, excavations carried out in the cemetery surrounding St Michael's Church on Greenhill, close to a tributary of the River Trent, turned up a complete flint flake and four broken blades. These were multi-purpose utilitarian tools but mainly used for butchery and skinning leather.

The Neolithic started around 4,000 BC and saw the adoption of a sedentary lifestyle, rather than the nomadic hunter-gatherer lifestyle of the Palaeolithic and Mesolithic. Plants and animal species were domesticated using agriculture, and woodlands started to be cleared. Dwellings known as 'long houses' were built, housing both people and animals. Flaked axes became polished, improving both the appearance and the functionality of the axe.

Several shallow Neolithic pits have been found during sewer cutting work between the college and Minster Pool. These contained flint tools, pottery, burnt stones (used to heat water) and traces of charcoal and burnt bone. Originally the area south of the cathedral dropped gently southwards towards a wide stream, pond or marsh. The earliest ground surface was 4 metres below the current surface and was 25 metres further north. Over time, the pool bank has been improved and reconstructed to form the current bank line.

The discovery that copper ore could be broken down and heated to produce a material that could be formed into objects heralded the start of the Bronze Age, around 2,350 BC. Bronze, a mixture of copper, tin and other metals, was significantly stronger than copper by itself, and became the favoured metal for tools. The first tools that were made were flat axe heads. Over the centuries, the sides of the flat axe heads were raised up and became palstaves, finally culminating in a socketed axe.

Houses changed shape from long houses into circular 'roundhouses'. There was an increase in monument building, particularly in the Peak District, with major concentrations of round burial mounds visible. Monuments tended to focus on key landscape features, such as hilltops or false horizons. Ring ditches were concentrated in the river valleys, with a particular focus around Catholme and Whitemoor Haye. Some may have started in the Neolithic, but saw a continuation in use, mostly as a focal point.

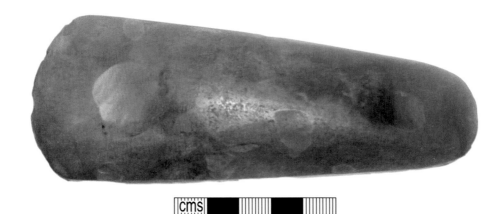

A polished Neolithic axe head from the Lichfield District Council collections. A similar one was found in Gaia Lane during the 1960s. (Copyright: Lichfield District Council)

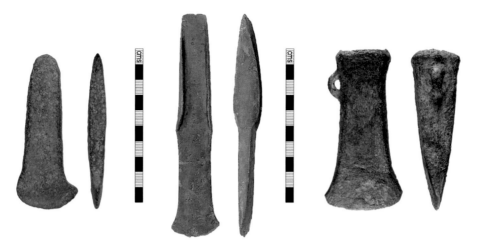

Left: a flat axe head (WMID-0F3992). *Middle*: a flanged axe head (LANCUM-2526B8). *Right*: a socketed axe head (WMID-D16B77). All were found close to Lichfield. (Copyright: Birmingham Museums Trust & the Portable Antiquities Scheme)

Lines of burial mounds called barrows appeared amongst the ceremonial landscape at Catholme and Whitemoor Haye.

An early Bronze Age developed flat axe head (WMID-0F3992), dating to around 2050 to 1700 BC, was discovered close to Knowle Hill. Other metal detector finds include a gold working anvil, two palstaves and a socketed axe, acquired by the British Museum. Traces of gold are embedded in the surface of the anvil, and a groove on the side may relate to making gold bracelets. It is probable that a burial mound was on top of Knowle Hill.

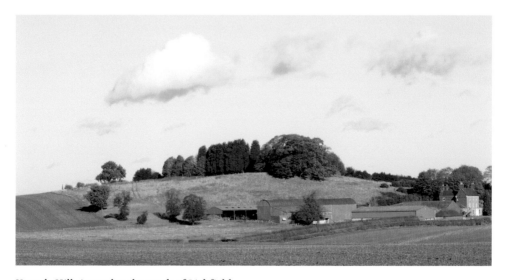

Knowle Hill situated to the south of Lichfield.

Right: The gold-working anvil found during excavations at Knowle Hill by a team from the British Museum back in 1990 and 1991. (Copyright: The Trustees of the British Museum).

Below: *Top*: a rolled fragment of decorated ribbon (WMID-807E61A 2020T107). *Bottom*: an octagonal-shaped gold rod (PAS-83D4C4 2005T517). Both were found close to Lichfield. (Copyright: Birmingham Museums Trust & the Portable Antiquities Scheme)

Over recent years, fragments of Bronze Age gold bracelets discovered as metal-detecting finds, demonstrating gold working in the area. A length of gold rod with an octagonal cross section was recovered through metal detection on the outskirts of Lichfield, near Mickle Hills. The shape of this gold rod is like those discovered in Bronze Age hoards found in other areas of the country.

A Late Bronze Age burial was discovered near Greensborough Farm, Shenstone. Fragments of human bone, decayed wood, and a hoard of twenty-one bronze implements were uncovered when labourers were enlarging the rickyard of the farm. Making up the hoard was a sword, broken in two pieces, another sharp sword or dagger, a spear head, and fragments of two more palstaves and socketed axes.

Around 800 years BC, iron ore started to be smelted to produce iron. Bronze continued in use, but iron became the favoured metal for weapons and tools, being stronger and lighter. The roundhouse tradition continued into the Iron Age.

Three tribal groups are known to cover Staffordshire: Dobunni to the south (Gloucestershire), Cornovii to the west (Shropshire & West Staffordshire) and Corieltauvi to the east (East Staffordshire and North Warwickshire). Lichfield is close to two hill forts: Castle Ring at Cannock Chase and Castle Hill Old Fort at Stonnall.

Stray Iron Age finds have been recorded through metal detecting in the landscape surrounding Lichfield. A miniature terret ring was found near Knowle Hill, dating from 100 BC to AD 100. Terret rings are used to control reins on a chariot.

Further afield, near Elford, in 2013 a hoard of thirty-three gold coins (staters) were found, all originating from the Corieltauvi tribe and most likely produced between 40 BC and AD 30, in the Lincolnshire region. This hoard doubled the number of staters previously known in the county.

These coins were made by heating up a small but consistent amount of gold, silver or copper in ceramic moulds, similar to BH-95F015 from Standon, Hertfordshire, to produce blanks. These blanks were then flattened, before being struck using dies made from iron or bronze, and engraved with a particular inscription or artwork.

Silver coins (denarii) from the Roman Republic have been found in Wall, suggestive of occupation prior to AD 43. These coins are not uncommon finds within Staffordshire, as they were used in trade as silver bullion, not as money. Two denarii were found in the paddock of the White House, Wall. These coins name two different moneyers: Decimus Junius Silanus and Lucius Marcius Philippus. The office of Moneyer at the official mint was regarded as one of the more desirable junior magistracies and the role was often held

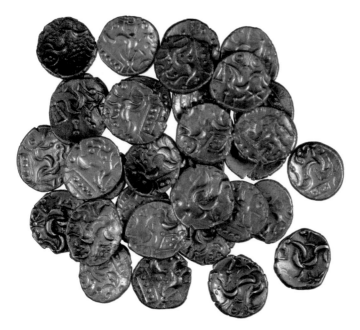

An Iron Age coin hoard formed of thirty-three gold staters and found in Elford (WMID-092343 2013T157). Acquired by the Potteries Museum, Stoke-on-Trent. (Copyright: Birmingham Museums Trust)

by members of influential families in Rome. Records have survived of who was magistrate and when, and so republican denarii can often be dated to a particular year; in this case it was 91 BC for Decimus Junius Silanus and 56 BC for Lucius Marcius Philippus. Due to their high silver content, these denarii often stayed in circulation for many years until the coinage was debased and recalled during the reign of Nero in AD 54–68.

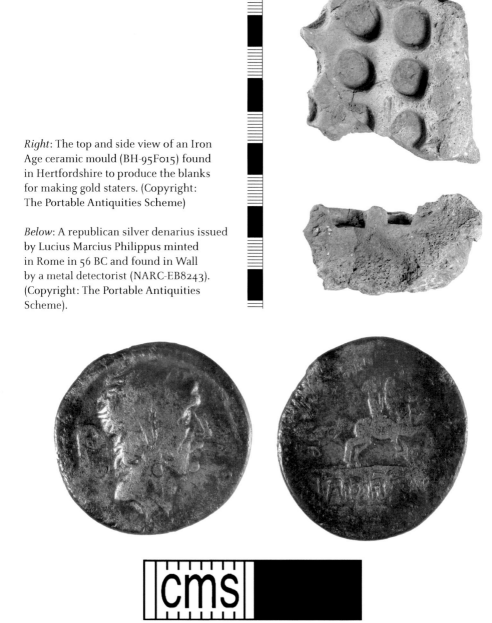

Right: The top and side view of an Iron Age ceramic mould (BH-95F015) found in Hertfordshire to produce the blanks for making gold staters. (Copyright: The Portable Antiquities Scheme)

Below: A republican silver denarius issued by Lucius Marcius Philippus minted in Rome in 56 BC and found in Wall by a metal detectorist (NARC-EB8243). (Copyright: The Portable Antiquities Scheme).

Wall

WALL n.s. [wal, Welsh; vallum, Lat. pall, Saxon; walle, Dutch.]
2. Fortification; works built for defence. In this sense it is commonly used plurally.
A prey
To that proud city, whose high walls thou saw'st
Left in confusion.
Milton's Par. Lost, b. xii.

Roman artefacts recorded by the Portable Antiquities Scheme demonstrate a high level of activity in the area surrounding the city but give limited evidence inside as the city is heavily developed. The focus of Roman occupation was to the south, on the nearby village of Wall. Small-scale rural farmsteads have occupied the area surrounding the city, explaining the spread of Roman material recorded.

Lichfield sits near the border of the 'civilian' zone in the south and east of England and the 'military' zone in the north and west of the country. The civilian zone tends to have towns, villas, temples, burials and a high level and variety of artefacts. The military zone is characterised with forts, *vici* (civilian settlements outside forts), 'native settlements' and a low level of artefacts. Acidic soils in this area of the country mean that wood and bone artefacts do not survive. Environmental evidence shows that it was a wooded landscape, with pine, alder, birch, elm, hazel and willow, with occasional oak trees. Natural water springs may have had a local religious focus.

Two Roman roads run close to Lichfield: Watling Street, now the A5, linking the provincial capital (initially Colchester, later London) to the tribal centre at Wroxeter and Ryknield Street, running from Yorkshire to the West Country. There would have been smaller trackways linking up farmsteads and other small settlements.

The village of Wall gained its name due to the Roman walls in the area. During Roman occupation it was called 'Etoceto' or 'Letocetum'. It was listed in a third-century road book, *The Antonine Itinerary*, as 'Etoceto'. In the seventh century, in the *Ravenna Cosmography* (based on earlier Roman material), the settlement gets called *Lectoceto*. Spelling was not standardised at the time, so now the Latin version, *Letocetum*, is used.

The earliest dwelling has been found near Crane Brook, Wall, and is of Early Roman or Native style. A ditch encircled the base of a small hillock, and inside were three truncated post holes and a linear feature. The post holes are the remains of a building.

The first phase of Roman occupation was that of a timber vexillation fortress, located near the current church, on top of a hill. It housed the XIV Gemina Legion during the campaigns against the Brigantes, led by governor Aulus Didius Gallus in the mid-50s AD. Under the reign of Nero, the fortress developed into a larger-scale posting station.

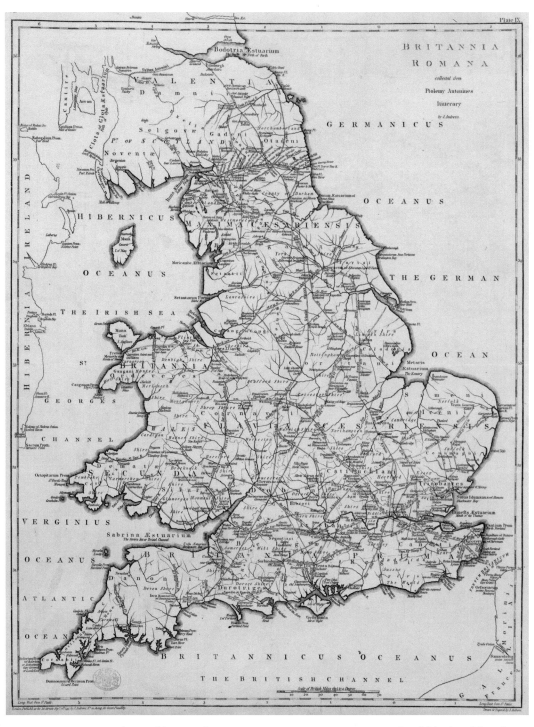

Roman Britain as depicted by J. Andrews in Britannia Romana, AD 1797. Ickneild (Ryknield) and Watling Street are shown close to Lichfield and Letocetum. (Copyright: The British Library)

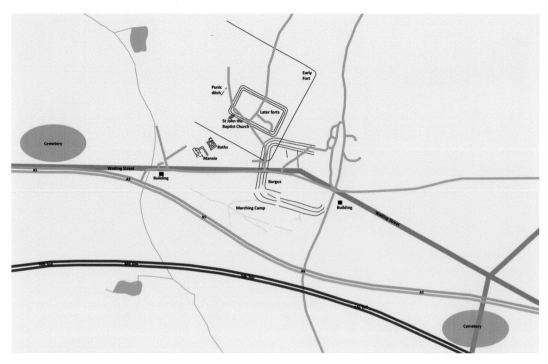

Map highlighting the locations of the early fortress, *maniso* and other Roman features in Letocetum.

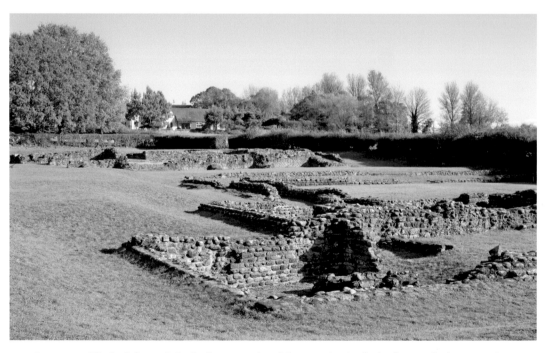

Letocetum. The bath house is in the foreground and the mansion in the background. These remains are free to visit and open most days.

The earliest fort occupied at least 30 acres and was the largest of all the fortresses on the site. The troops were eventually moved down Watling Street to Viroconium (Wroxeter).

The first main structure was the *mansion*, situated to the west, near to the site of a pagan shrine to the Horned deity. Nine carved stones were found reused in the walls of the *mansio*. This building provided lodgings for the official couriers travelling up and down Watling Street. Alongside the *mansio* came the bath house. The *mansio* comprised bedrooms, offices, dining room, kitchen and an overseer's suite. It probably had two storeys, with more bedrooms on the first floor. Alongside was a bath complex complete with an exercise yard, and hot and cold baths.

By the end of the second century, the settlement at Wall was spread alongside the road, reaching almost 2 miles long. By the late fourth century, a burgus – a small, defended area with no buildings – was created, as a refuge for travellers and settlers away from danger. The latest coin found during excavations dates to the reign of Gratian in 381. In advance of the M6 toll road being built to the west of *Letocetum*, a cemetery was discovered. It consisted of twenty-one burials and forty-two cremations. A stone coffin was found to the east of the baths.

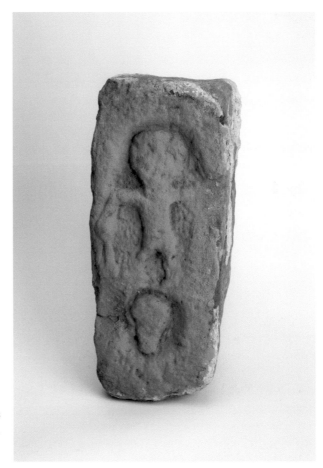

One of nine reused carved stones found at Wall, from an old temple complex. This one depicts a horned warrior above a severed head. (Copyright: Birmingham Museums Trust)

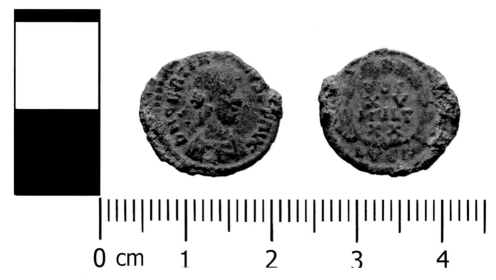

A nummus of Gratian, VOT XV MVLT XX reverse type celebrating his fifteenth anniversary and hoping for his twentieth anniversary of his rule (BM-3704CA). (Copyright: The Portable Antiquities Scheme)

Over the years, various excavations have provided more information, such as a small bronze-working hearth. Two unusual Roman brooches were also found during the excavations in 1960, both were donated to the British Museum. The first has parallels with Hofheim and Novaesium in Germany and is a plate brooch with openwork enamel decoration. The second takes inspiration from the Hod Hill type but with more elaborate decoration. These brooches demonstrate trade with Germany and the wider empire.

Samian pottery, an imported type of pottery, has been found in the infill of some of the inner ditches of the fortresses. Samian is a glossy red slip coated pottery, often mould made with raised pictorial designs. It is tableware with cups, bowls and plates being the predominate forms as opposed to the utilitarian coarse wares which tend to be storage jars, with a few beakers and bowls.

A bronze bowl, with a Chi-Rho monogram, was found in 1922, accompanied by a stone with the same symbol. This symbol is made up of Chi and Rho – two Greek alphabet letters – and was used by Early Christians.

Closer to the city centre, other interesting Roman finds have been discovered, demonstrating a small degree of Roman occupation in the area. A possible gypsum burial, within a lead coffin, was found in 1751 beneath the floor in the south aisle of the cathedral. This burial practice involved pouring liquid plaster or gypsum over the corpse in a coffin to create a cast. Elsewhere in the Cathedral Close, a Roman tile was found.

Excavation on the southern side of Sandford Street revealed a ditch 2 metres wide by 2 metres deep, parallel to the realigned south-west–north-east course of Friar's Alley. This ditch had been recut before, and the lower parts of the fill contained Roman pottery and higher parts medieval. This shows that that boundary has been there since the Roman period.

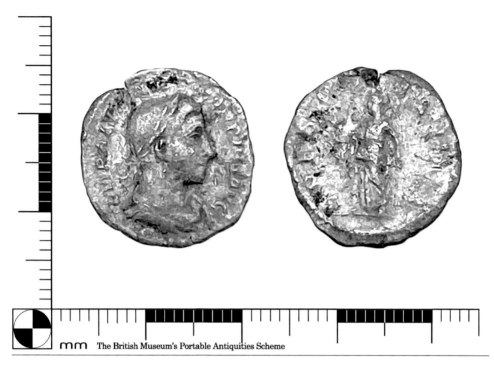

mm The British Museum's Portable Antiquities Scheme

A Severus Alexander denarius like this (BH-12F5DB) was found at Ash Grove. (Copyright: The Portable Antiquities Scheme)

A hoard of twelve denarii (WMID-104649) was found near Sandfields back in the mid-1990s, all dating to the first or second century, the equivalent to two weeks' pay for a legionary soldier. Three Roman coins were found at Ash Grove, Lichfield, in 1969. One was a denarius of Severus Alexander, and the other two were late Roman nummi of Constantine I and Constantine II. Severus Alexander was fourteen when he became Emperor after his cousin, Elagabalus, was assassinated by the Praetorian guards in 222. He remained Emperor until 235 when he was murdered while on campaign in Germany by the troops loyal to one of his commanders, Maximinus. Constantine I was Emperor nearly a century later, in 306. During his reign Christianity became legal in the Roman Empire. He died in Constantinople (modern Istanbul) in 337. Constantine II succeeded his father, and during his reign the Roman Empire was divided into East and West, with Constantine II taking control of the Western side, including Spain, Gaul and Britain. He died near Aquileia, Italy, in an ambush. These coins illustrate that trade was occurring in the area during the third and fourth centuries AD.

3

Ho'ly

HO'LY adj. [halig, Saxon; heyligh, Dutch, from Hal, healthy, or in a state of salvation.]
1. Good; pious; religious.
See where his grace stands 'tween two clergymen!
And see a book of prayer in his hand,
True ornaments to know a holy man.
Shakesp. Rich. III.

The Roman occupation officially ended in 410 but the country did not stop being 'Roman' overnight; instead it declined gradually. The upkeep stopped on public buildings like the *mansio* at Wall, and they gradually decayed. Coins stopped being used for trade and the economy switched back to a barter economy. Houses were rectangular thatched dwellings and farming carried on as before. Over the next 400 years, society would change with the development of kingdoms and sub-kingdoms, eventually merging to form a united England.

People carried on living in the *Letocetum* area, but the focus switched back to the hill surrounded by various brooks and marshes. *Marwnad Cynddylan*, a seventh-century Welsh poem, mentions 'Caer Lwytgoed' (town of the grey wood) and refers to an attack upon Caer Luitcoed (near Lichfield) by the men of Powys in the reign of Cynddylan. During this raid, they carried off 'extreme booty' including 1,500 cattle and probably five herds of swine, much of the battle-train's moveable wealth. The book-holding monks there could not offer protection. Other poems state that Cynddylan was alongside Penda at Oswestry in 641 when the two kings fought against Oswald. Therefore, it is reasonable to assume that this poem dates to around 655, celebrating a victory over Oswiu's Northumbrian forces at Lichfield.

A fifth- to seventh-century rectangular building destroyed by fire was found during the construction of the Lombard Street multi-storey car park. The interior walls had been rendered with a mud plaster. Environmental remains included charred rye, free-threshing wheat grain, hulled wheat, barley and lots of cultivated weeds, suggesting that crops had been stored prior to threshing. Radiocarbon dating indicates that this building was present prior to Chad's establishment of the Mercian Bishopric. This building was later reused between the seventh and eighth centuries by removing the demolition material and keeping the original north-west wall. The floor was lowered, creating a 'Sunken-floored-building', and used for storage of crops prior to threshing and a couple of hearths.

In 653, Peada, son of Penda, King of Mercia, converted to Christianity when he married the daughter of Oswiu, King of Northumbria. Four missionaries from Northumbria came to the area to start preaching to the natives. Two years later, in 655, after winning a battle against Penda, Oswiu established Peada as the king of the Southern Mercians. One of the

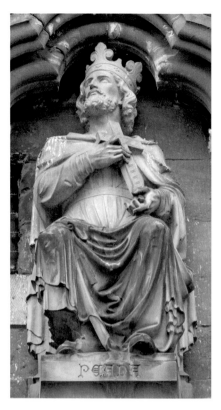 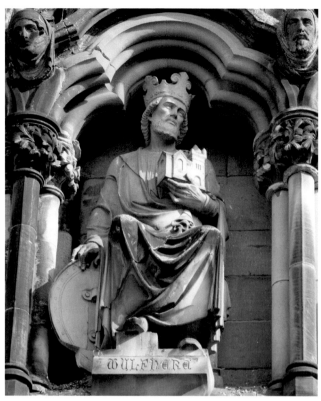

Above left: Statue of Peada, King of Mercia, on the west front of the cathedral.

Above right: The statue of Wulfhere, Peada's brother and King of Mercia, on the west front of the cathedral, holding a model of Peterborough monastery.

original four missionaries, Diuma, was consecrated as the first bishop of the Mercians, the Lindisfaras and the Middle Angles.

Wulfhere, Peada's brother, took control of Mercia in 658. Amongst the estates that were granted to Wilfrid, between 667 and 669, was Lichfield, as a monastery or minister had been founded there. Wulfhere tended to give Wilfrid places in Mercia where he founded monasteries. In Northumbria and likewise Mercia, Wilfrid claimed the churches that the British clergy had fled from because of Saxon attacks. Wilfrid appointed Chad as Bishop of Mercia in 669.

Chad was born around 634, up in Northumbria. He was one of four brothers, all of who entered the priesthood, with two of them later becoming saints. He studied initially at Lindisfarne, under Aidan and Cuthbert, and later moved over to Ireland. He became Bishop at Lastingham (Yorkshire) in 664, and soon after became Bishop of York. This bishopric was resigned in 669, with him being appointed Bishop of Mercia. After travelling around Mercia, Chad selected the church of St Mary, positioned on a high ground, surrounded by brooks and marshland to be the new centre of his bishopric. This area of high ground is where the cathedral is today.

Statue of St Chad in the Cathedral Close, designed by Peter Walker and erected in 2020. Chad is holding the Bible in his left hand and his right hand is held up in blessing.

Chad tended to worship in the Church of St Mary during the day, but his place of lodgings was a monastery to the east, close to a holy well. Baptisms were carried out in the well and Chad received his vision of the Heavenly Host coming to tell him his time was nearly up on Earth. He died on 2 March 672 from the bubonic plague. He was buried by Bishop Hedda in St Mary's Church but then his bones were translated to the Church of St Peter next door where a shrine was built in his honour.

A cult dedicated to St Chad quickly sprung up following his death in 672, and Bede records that frequent healing miracles were attributed to him. By the late eighth to early ninth century, there was a shrine dedicated to St Chad. The 'Lichfield Angel', discovered in 2003 when excavations were carried out in the cathedral choir, was likely to be part of that early shrine. This carved stone fragment depicts a figure with a halo and wings, standing, holding a long staff in his left hand, and holding his right hand up in blessing. This pose and gesture identify the angel as the Archangel Gabriel. Traces of paint remain which indicates that the halo would have been gilded and the wings painted with shades of red, pink and white. He also had blonde hair. The size and shape of the fragment is consistent with that of a house-shaped stone shrine, originally to hold the wooden coffin-shrine that contains St Chad's remains. The iconography is suggestive of nineth-century dating. When excavated, the fragment was found within a burnt structure and had been deliberately broken up and buried. A penny of King Edgar, who ruled between 959 and 975, was found within that burial context, which suggests that the final burial happened before the end of the tenth century.

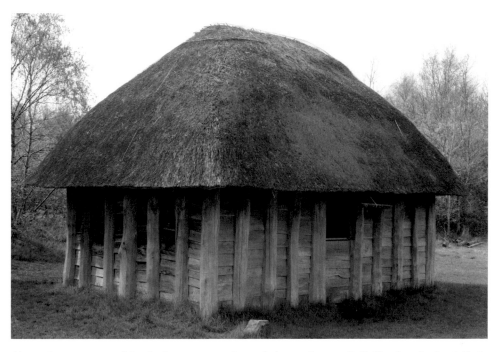

Above: A reconstructed Anglo-Saxon monastic workshop at Jarrow Hall, Northumberland. Bede described a monastery with 'cells that were built for praying and reading'. (Copyright: Greg Robson)

Below left: The Lichfield Angel, on display at Lichfield Cathedral. (Copyright: David Rowan)

Below right: The statue of Edgar, King of England on the west front of the cathedral.

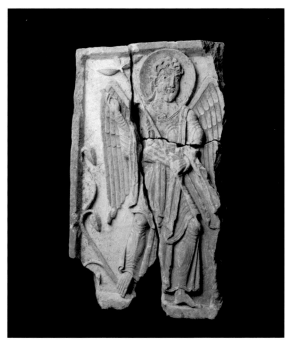

When restoration work was carried out inside the cathedral in the mid-1990s to replace the broken limestone flagstones, evidence of two early churches was found. These are thought to be the Church of St Mary and the Church of St Peter. Later these two merged into the current cathedral, which was started around 700. This first shrine, or the 'Mercian Shrine', was positioned in what is now the cathedral nave. It was later moved to the east end behind the altar. It became a focus for high-status burials with eventually three kings being buried within its walls. King Wulfhere in 674 was the first, then Coelred in 716, and eventually Ethelbert, King of the East Angles, in AD 794.

In 2009, on the outskirts of Lichfield, close to Ogley Hay, and near Watling Street, the Staffordshire hoard was uncovered by a metal detectorist. This hoard was the largest hoard of Anglo-Saxon gold and silverwork found at the time. It comprises predominately 'war loot', such as sword pommels, a helmet and religious church items including three crosses and part of some priestly head gear. The area where it was buried was relatively sparsely occupied. It may have been a significant boundary between two folk groups, separated by the Cannock Hills, the Pencersæte to the west and the Tomsæte to the east. The material in it represents two different tribal styles: East Anglian and Northumbrian. The earliest date for the burying of the hoard is from around 650 to 675, around the time when Chad came to Lichfield. The hoard has been acquired by Birmingham Museums Trust and the Potteries Museum and Art Gallery, and is on display at both.

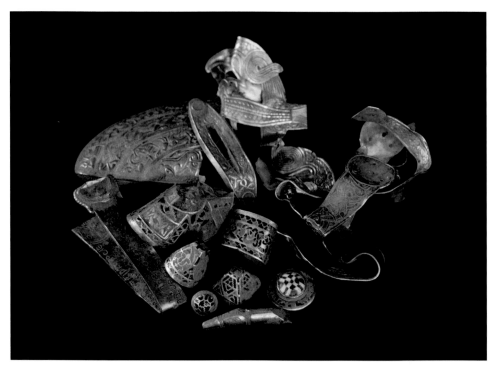

The Staffordshire Hoard, the largest collection of early medieval gold and silverwork, discovered in July 2009. Jointly acquired by Birmingham Museums Trust and The Potteries Museum and Art Gallery. (Copyright: Birmingham Museums Trust)

Excavations in 1976 on the south side of the cathedral uncovered several large and small structures made from timber alongside a marshy pond. These are thought to be part of the first ecclesiastical Middle Saxon timber-built settlement, and later destroyed by a Late Saxon secular cemetery. Another early medieval cemetery was discovered when excavations were carried out for the construction of modern school buildings for the cathedral school in 1987. Two eighth-century T-shaped axes were found when alterations were made at the Chancellor's house.

During groundwork for the Theological College in the Close in the 1970s, several graves, orientated with heads to the west and no grave goods, were discovered. The presence of Stafford ware and local wheel-thrown limestone-tempered pottery types dated them to the late Saxon period.

When Stowe and Minster Pool were drained, prior to being turned into a reservoir in the mid-nineteenth century, several artefacts were turned up, one of which was an incomplete copper alloy spiral-headed pin, typically of seventh-century dating. This is a union pin, as it was used in pairs, with their heads joined possibly by threads rather than the more usual chains.

Offa persuaded the Pope to make Lichfield an Archbishopric covering lands between the Humber and the Thames, and a similar authority as Canterbury. The Archbishopric was short-lived, dissolved three years after Offa's death in 796. It returned to being an ordinary Bishopric, with Bishop Ealdwulf in charge. By 823, a community of nineteen canons was present at the cathedral.

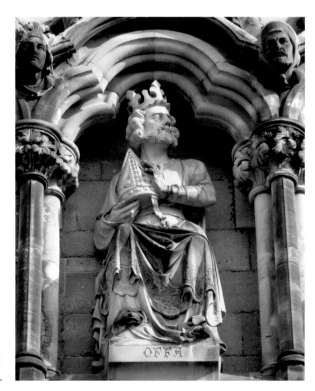

The statue of Offa, King of Mercia on the west front of the cathedral. The bishop's mitre in his hands represents him asking Pope Adrian I to create the archdiocese of Lichfield.

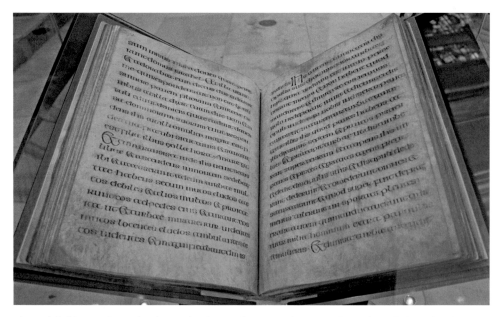

The Lichfield Gospels, on display in the chapter house. Each new Bishop of Lichfield makes his oath of allegiance whilst holding the Lichfield Gospels.

The Lichfield Gospels (also known as St Chad Gospels or Book of Chad) is an eighth-century manuscript and an outstanding example of Insular manuscript art. It was originally two volumes, but one is now missing. The surviving volume contains the Gospels of Matthew and Mark and the start of Luke. Where it was made is uncertain – either Ireland, Northumbria, Wales or Lichfield. In the ninth century it was in Llandeilo Fawr, Carmarthenshire, and by the tenth century it had reached Lichfield. Whilst in Llandeilo, various additions were added. These additions are probably those of people to be commemorated at the altar at Llandeilo. Alongside the artwork on three pages are 'dry-point glosses'. These are impressions made by the stylus with no ink, so hard to spot without raking light. These glosses provide the names of several Anglo-Saxon personal names: Wulfun, Alchelm, Eadric, Berhtfled, Elfled and Wulfild, likely informal commemorations of members of the religious community there.

The 'Sunken-floored building' down at Lombard Street was rebuilt during the eight to tenth centuries, keeping the pit beneath but enlarging to the north-west. The sides of the building were made from wattle and daub, which survived as a pile of collapsed burnt material, indicating that the building was burnt at the end of its life. This burning and the destruction of the first shrine of St Chad are potentially evidence of a raid on the cathedral in 972 when the Great Viking Army overwintered at Repton. After they overwintered, the Great Viking Army split in two. One half went north towards York and the other went south following the river past Tamworth and towards Cambridge. No raids are recorded in the Anglo-Saxon Chronicle. Five Viking cigar-shaped ingots have been found near Shenstone. These date from the late ninth to tenth centuries and were used as both a raw material for metalworking and as currency within a bullion economy.

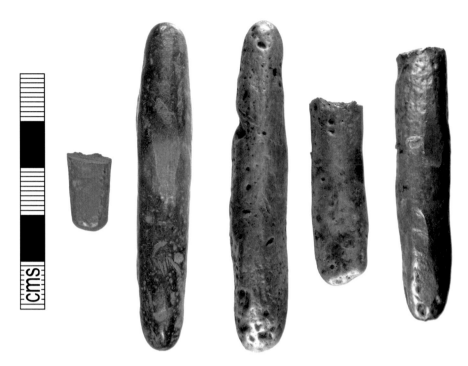

Five silver cigar-shaped ingots found near Shenstone, characteristic of a Viking bullion economy. All acquired by the Potteries Museum and Art Gallery. *From left to right*: WMID-0B3FC7 (2011T555), WMID-F6EEF0 (2009T194), WMID-C36B61 (2013T411) and LVPL-E032D7 (2021T96). (Copyright: The Portable Antiquities Scheme)

Northwest of the 'Sunken-floored building' at Lombard Street, another structure was uncovered, which dates to the tenth to twelfth centuries. The building consisted of two rooms: a larger eastern space and a smaller western room. Metalworking debris was found, including five smithing hearth bottoms. A large pit was found to the west of the building, containing a barrel lining. Within the barrel, the fills alternated between clean silty sands and compacted dark organic material (rotted wood and straw). The pit has been interpreted as the waste from flax retting or linseed oil extraction processes.

Heavily worn fragments of Early to Mid-Saxon pottery turned up on Sandford Street during an excavation.

An undated post pit was discovered at St Michael's Church during work to extend the vestry in 1979. This pit is one of the earliest features on the site and contained several irregular sandstone fragments and could have been evidence of earlier Christian or secular activity. Forty-nine burials were found, with all but two laid out straight, with heads to west, in a normal Christian manner. A crouched burial was also found, oriented with head to the west, which is unusual because this funeral practice is not typically found during the Anglo-Saxon period. Another unusual burial was that of an adult and small baby together, likely a mother and baby who died at, or around, the time of childbirth.

4

Cathe'dral

Cathe'dral n.s. The head church of a diocese.
There is nothing in Leghorn so extraordinary as the cathedral, which a man may view with pleasure, after he has seen St. Peter's.
Addison on Italy.

From 1000, the cathedral developed as a major religious centre and the city grew up to provide accommodation and food for the pilgrims visiting the shrine of St Chad. As the cathedral and shrine prospered, so did the city. Trade guilds developed and a Franciscan friary was founded to serve the poor and needy. Bars and a ditch were built around the edges of the town as a boundary. A Close is marked out around the cathedral by a large ditch (known as a dimble) to the north, east and west. This Close marked out the area of land owned and managed by the Church. Watercourses, mainly the Trunkfield and Leamonsley brooks, were managed, and fish pools were created to provide fish for feast days.

The 1086 Domesday Book entry for Lichfield, located in the Offlow hundred, noted a recorded population of 9.9 households and 2 mills, worth four shillings. Nearby settlements included Stytchbrook, with 9.9 households and 2 mills, worth four shillings. A deserted settlement known as Litelbech is thought to be where Boley Park is, with 5.5 households. All the land was the property of the Bishop of Chester (St John). The church at Lichfield was only a collegiate church with five canons assigned, with St Chad recorded as its patron saint.

Between 1072 and 1228 Lichfield lost its cathedral status, as the Bishop's seat moved initially to Chester by Bishop Peter in 1072 and then to Coventry in 1102 by Bishop Robert de Limesey, now the Bishop of Coventry and Lichfield. Until Coventry Cathedral was dissolved in the sixteenth century Coventry was the main centre for the diocese.

A tenth- to eleventh-century cemetery was discovered during excavations in the Close. A spearhead of similar date was found amongst the material removed from Minster Pool during the nineteenth-century dredging. Worn sherds of Stafford ware pottery, dating to around the tenth to eleventh centuries, were discovered on an excavation just south of the medieval pool bank, west of Bird Street.

The arrival of Roger de Clinton as Bishop in 1126 offered new life to the former episcopal centre. He finished the work that two earlier Bishops – Limesey and Peche – started and replaced the Saxon cathedral with a Norman one. This building had a cruciform shape, with an apsidal presbytery, and Chad's shrine was situated close to the high altar. By the mid-thirteenth century, the church had recovered its cathedral status, and it had four dignities (dean, treasurer, precentor and chancellor), a greater number of canonries and its first statutes.

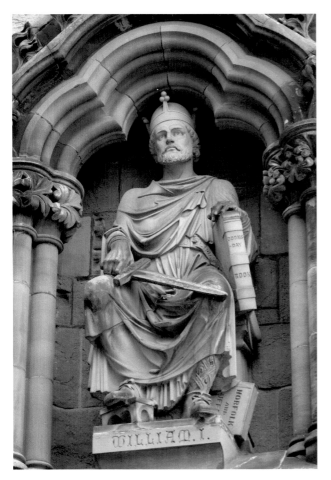
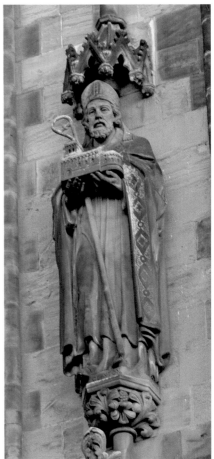

Above left: Statue of William I on the west front of the cathedral, holding a sword in his hand. Resting on his lap is a copy of the Domesday Book.

Above right: Statue of Bishop Roger de Clinton on the west front, holding a model of the cathedral he designed.

De Clinton was responsible for the layout of the 'new' town, south of Minster Pool, created by the impounding of the Leamonsley and Trunkfield brooks with a mill and dam at Dam Street. This dam, together with quarrying to get sandstone blocks to build the cathedral, created two fish ponds: the Minster Pool and the Bishop's Pool. Fish ponds were important as religious doctrine dictated that on Fridays and saints' days only fish could be eaten, not meat. Being non-coastal, marine fish could not be acquired and a nearby ready stock of fish was required – hence the ponds.

As part of the city layout with organised streets, a ditch was dug around the extents of the city, with bars placed at each road entrance. City bars were erected at Sandford Street, Stowe Street, Tamworth Road, and St John's Street (Culstubbe Gate). A curfew operated with the bars, closed each evening between 8 and 9 p.m. and opened at 7 a.m. A hospital

was built outside the Culstubbe Gate by the Augustine canons who operated it not only as a hospital for the sick but also to provide food and lodgings for those travelling to the city. This was the Hospital of St John the Baptist Without the Barrs.

City planning was continued by De Clinton's successor, Bishop Durdent. By 1159, 286 burgage plots were created, each yielding a rent of one shilling per year, payable to the Bishop. There were fixed market stalls, with an annual rent of one shilling and five pence. Markets were held in front of St Mary's Church and on Bore Street. The latter was originally known as Board Street as goods for purchase were displayed upon boards.

Around the 1160s, the eastern chapel of the cathedral was replaced by a three-bay rectangular chapel. This extension was to provide ease of movement around the shrine. The choir was extended to seven bays around the 1190s. The first bishop to be buried in the cathedral was Bishop Muschamp.

Henry II presided over a trial in Lichfield in 1175. The trial found the murderers of a royal forester guilty, the first documented execution of criminals in Lichfield.

Between 1170 and the 1230s a square east end, a two-storeyed chapel and a crypt were added to the cathedral under instructions from Dean Mancetter. The ground-floor chapel

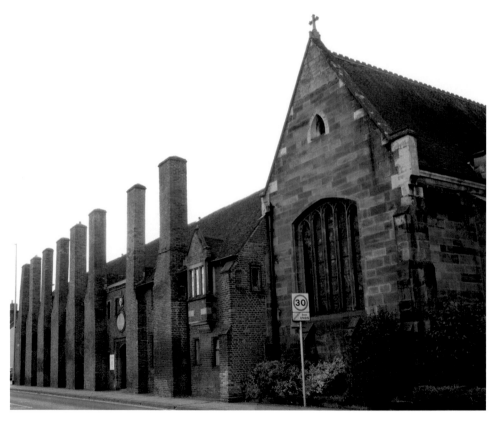

The Hospital of St John the Baptist Without the Barrs. The current frontage is of sixteenth-century dating, with eight distinctive chimneys. The chapel is to the right and living accommodation is to the left.

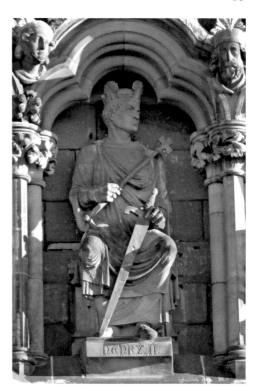

Right: Statue of Henry II on the west front of the cathedral, holding a sceptre and sword.

Below: The tomb of Dean Mancetter can be seen on the south side of the cathedral, close to the south door on the outside.

was dedicated to St Peter and used as a consistory court from 1255 to 1340, as the chapel was used for conducting business. The upper storey held St Chad's relics and was named the Chapel of St Chad's Head.

A short-lived coinage mint operated during the reign of Richard I. A charter of 1189 granted a pair of dies to Hugh de Nonant, Bishop of Coventry, for use in Lichfield. To date four coins (two pennies and two cut-half pennies) are known, struck by moneyer Ioan. Bishop Hugh had high political ambitions and spent plenty of time with the King,

Statue of Richard I on the west front of the cathedral, holding a crusader flag.

A penny of Richard I, minted at Lichfield by moneyer Ioan. (Copyright: The Trustees of the British Museum)

especially while Richard I was imprisoned in Germany between 1193 and 1194. Bishop Hugh was stripped of his minting rights by the Archbishop Baldwin of Canterbury for dabbling in secular offices.

Stowe Pool was created in the twelfth to thirteenth centuries by building dams over the Curborough Brook. A mill was built near St Chad's Church which ground wheat and other grains, with a tithe payable to the bishop.

In 1221 Henry III gave twenty oaks from Cannock Forest to the Chapter and Church, followed ten years later by timber from Ogley Hay for ladders. Quarry permission in Hopwas Hay was supplied in 1235 and 1238, for supplying stone for the cathedral. The north transept was completed by 1241 as Bishop Patteshull was buried before

The monument dedicated to Bishop Patteshull in the cathedral, located in the south aisle.

St Stephen's altar in the east aisle. In 1243, the transept vault roof at Lichfield was copied for the royal chapel at Windsor by Henry III.

On the outskirts of town, the Minor Brethren of Lichfield founded a Franciscan friary, established by Bishop Alexander Stavensby around 1237. Most of the buildings were completed by 1286. The charitable order of St Francis (Franciscans) worked with the poorest in the community, including lepers, and were nicknamed as 'Greyfriars' because of the grey woollen habit they would wear. The first friary had an unusually large church with a five-bay nave and chancel, with massive foundations, indicating a crossing tower of considerable size, built out of timber. A passage from the chancel led to a 24-metre-square cloister. Not long after the completion of the building work the friary was destroyed by a catastrophic fire around 1291, along with a large chunk of the medieval town. It was quickly rebuilt, this time in stone. The church had an aisled nave with an aisleless choir, and some of the north wall still stands today at a height of 0.8 metres. The associated cemetery extended north into Bird Street. Unfortunately the friary never recovered after two-thirds of the friars died during the Black Death in the 1340s.

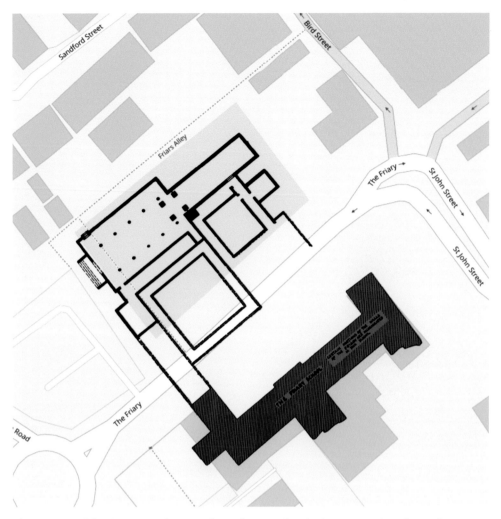

The remains of the Franciscan friary as drawn by P Laithwaite in 1934, against the modern street map. (Copyright: Google Maps)

The friary's precinct wall extends to the rear of 15 Sandford Street, where footings of a substantial masonry wall were found, built above two tanning pits which contained twelfth- to thirteenth-century pottery in their fill. A third tanning pit, containing thirteenth- to fourteenth-century pottery, was sealed beneath the wall. Similar-dated pottery recovered from the construction trench of the wall suggests that it was contemporary with the construction of the friary. This evidence shows that the friary had encroached upon ground that had previously been used for a single industrial process. Almost a hundred years after the friary was founded, it extended northwards and southwards.

In 2016, Wessex Archaeology undertook an investigation in the car park to the side of the friary building. They discovered the old boundary ditch, which appears on Snape's 1781 map of the City and Close of Lichfield. Within the ditch fills, thirteenth-

to fourteenth-century whiteware pottery fragments were found, and the remains of two shoes. Both shoes were of the turn shoe style, as they were sewn together initially with the seams on the outside and then 'turned' inside out to finish. The more complete shoe was that of an adult male, shoe size six. The other shoe was for a smaller adult, with a foot size three. The larger shoe was of a fashionable style, with a rounded toe, open front and low sides. It had been heavily worn as it had been repaired. A similar style, although more pointed, can be seen on several individuals in 'The Adoration of the Magi', a fifteenth-century North Netherlandish painting.

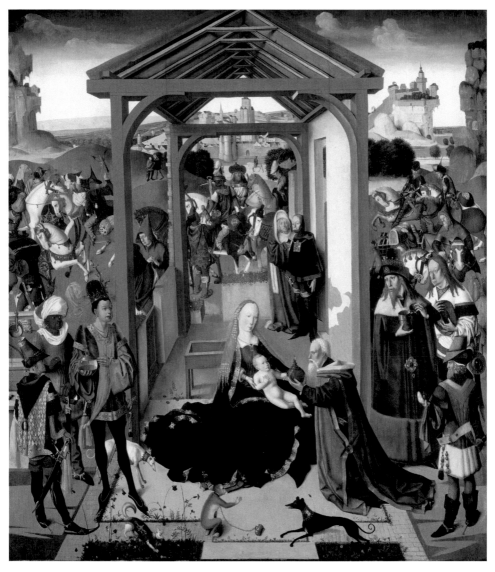

The Adoration of the Magi, a North Netherlandish fifteenth-century painting. (Copyright: National Gallery of Art)

By 1249, work had started on the cathedral chapter house in an elongated octagon shape, with a ten-celled vaulted roof. The west front, with the screen of tiers of statues, began after the rebuilding of the nave by Bishop Meuland. The lowest order contained the twelve apostles, four evangelists and Moses and Aaron in the central doorway porch. The Virgin and Child was placed centrally in the doorway, with Christ above. The second tier depicted the Kings of Israel or Judah and that of England with St Chad in the centre. The third tier, flanking the west window, had two rows of prophets, prophetesses and judges. Above the west window, in a niche, was another statue of Christ. Figures of patriarchs covered the face of the north and south towers. Inside the cathedral, above the west doorway, a text praising Oswiu, King of Northumbria, regarded as the cathedral's founder, was written. This was visible until the early eighteenth century.

The Hospital of St Leonard at Freeford was founded outside the city bounds to care for those unfortunate enough to contract leprosy, a disease that causes facial disfigurement and visible sores all over the body. In 1246, Henry III granted the hospital fifteen carcasses of salt pork from the stores at Nottingham Castle. In 1257, they were given five years of protection from the Crown. The hospital had land in Burway field (one of the common fields) and by the later thirteenth century they gained the penny's rent from a parcel of land outside the Tamworth gate. During the reign of Henry III, the hospital held two half messuages in the town itself. By 1333–4, it possessed land near Greenhill.

As Bishop, Walter de Langton ensured that the whole of Cathedral Close was walled, a ditch was built outside the walls and great gates were added to the west and south sides. A bridge was built over Minster Pool and the town streets were paved. A new Bishop's palace was built, with a Great Hall measuring 100 feet long and 56 feet wide. Houses were constructed for the dean and other clergy, as well as improvements made to their salaries. £2,000 (equivalent to £1.5 million today) was spent on a shrine to St Chad in the cathedral. The lady chapel was started, and money was bequeathed in his will for its completion. The chapel, with a three-bayed rectangle and a three-sided east end, had parallels in France as William Franceys, a French architect, is considered to have finished the work for Langton. He is noted as being Langton's mason in 1312–13. The chapel was completed by 1336, and figures of the ten wise and foolish virgins were placed on pillars in the chapel.

During the 1320s, a scriptorium was established. Alan of Ashbourne, a scrivener, produced what is now known as the *Lichfield Chronicle* but was originally called the *Book of Alan of Ashbourne* at the time of writing. The chronicle has several parts. These include the *De Gestis Anglorum* focuses on the history of the years 449 to 1322. Other historical sections include a set of annals from the Creation to 1292, a list of popes to 1317, a list of the Archbishops of Canterbury from Augustine (597) to Walter Reynald (1313), and a list of the Bishops of Mercia from Diuma (655–58) to Roger Norburgh (1324). Alan of Ashbourne based his work from various sources such as Gildas, Bede and Geoffrey of Monmouth's *Historia Regum Britanniae*.

Documents from the early thirteenth century record conduits and that clean drinking water was piped from the springs at Maple Hayes and Aldershaw. The Close had a private conduit from before 1290, sourced from Maples Hayes and gifted by a bellfounder, William de Pipe. In 1301, another Bellfounder, Henry from Aldershaw, granted the springs on his land to the Friars Minor for their use in perpetuity. The friars, being charitable, placed

Right: Statue of Bishop Walter de Langton on the west front, holding a church model.

Below: Map showing the approximate route of the conduit pipelines supplying the Close (Maple Hayes source) and the City (Aldershaw source). On the left is the Moses conduit in the Close and right is the modern Crucifix conduit by the old friary.

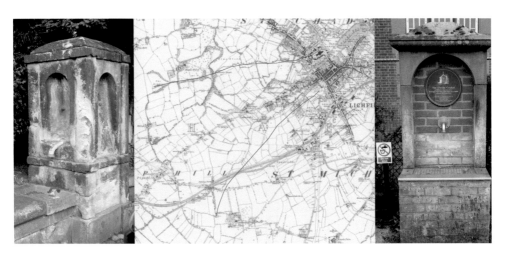

the conduit on the external wall, ensuring those in the city could use it. This became the Crucifix conduit.

St Michael's graveyard was first recorded in the thirteenth century by a documentary grant of land to the chaplains of the Chapel of B. Michael in exchange for prayers for the souls of the grantor's parents and their forebears who lay buried in the cemetery.

Excavations in the garden of 19 The Close revealed the remains of a fourteenth-century building. The wall at the bottom of the garden is the back wall of the property, which

backed onto Minster Pool. Part of a back-to-back garderobe survive, along with a window. This may have been a lodging house for pilgrims visiting St Chad's shrine during Bishop Langton's rebuilding of the shrine and the large lady chapel, or a house for one of the principal officers of the cathedral.

The current Church of St Chad dates from the twelfth century. Norman- and Early English-style windows can be seen within the church. The tower is of fourteenth-century dating, built to house the bells.

Vicar's Close was established in the fourteenth century to house the Vicars Choral. In the fourteenth century, Dean Heywood built the upper and lower courtyards for the Vicars Choral to be housed. Each vicar was given an allowance for food and shared a common hall and a small chapel. In exchange for their accommodation, strict rules were placed on them: they couldn't refuse food, and no gambling unless it was for ale; and no women or hunting dogs were allowed in their rooms.

The earliest guilds were religious based. St Chad's, St Mary's and St Michael's churches all had guilds attached to them from 1300. The Guild of St John the Baptist became attached to St Mary's Church in 1353 and eventually, in 1387, merged into the Guild of St Mary and St John the Baptist, thanks to a licence from Richard II. Guilds operated as part social club and part friendly society. Members paid an annual fee and in return the guild paid a chantry priest to say masses for the souls of its members. Trade guilds came later and there are records of two goldsmiths resident in Lichfield who belonged to the London Goldsmiths guild. They were Godfrey de Stafford, in 1267, and William Young, between 1317 and 1328.

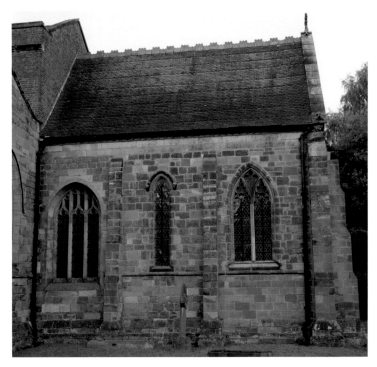

The exterior of the chancel of St Chad's Church, showing different window architectural styles. *Left*: fourteenth-century decorated style. *Centre*: thirteenth-century lancet. *Right*: fifteenth-century perpendicular.

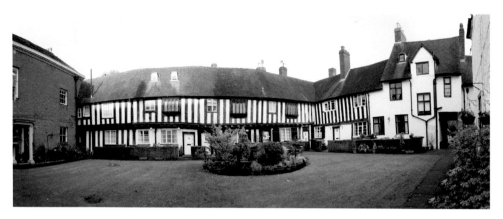

A panorama photo of Vicar's Close. Originally one up one down dwellings, with a communal dining hall in Vicar's Hall at the end and a small chapel above the archway for those too ill to perform their duties in the cathedral.

Edward III's royal visit happened in 1347, when he and his court came to stay to celebrate the English victory over the French at the Battle of Crecy. Celebrations lasted a whole week. During the day, jousting tournaments were held on land that is now Beacon Park, with feasting in the evening. Eleven of the King's knights battled against eleven led by Sir Humphrey Stanley. The Prince of Wales (The Black Prince) was one of the knights on the King's side. Soon after, Edward III inaugurated the Order of the Garter.

An account written by the sacrist of the cathedral in 1345 details the holy relics held. Along with St Chad's relics, there were fragments from Calvary, Golgotha and Oil of Saidnaya. The flask of oil is a souvenir of a visit to one of the older shrines of the Levant, Saidnaya, north of Damascus. The icon of the Virgin of the convent there was famed for its effusions of oil. It may have been given to the cathedral as a pilgrim's trophy or possibly as a gift from Edward I as he made other more prosaic gifts to the cathedral.

Richard II visited Lichfield three times. The first was in 1387 for the enthronement of Bishop le Scope, then ten years later for the full twelve days of Christmas, with Queen Anne and the royal court. They stayed in a house specially built for the royal couple in the Close and dined in a magnificent banqueting hall constructed by Bishop Langton. Wall paintings depicted previous kings of England. It has been estimated that during their stay, the King and his guests consumed 2,000 oxen and 200 barrels of wine. In the 1800s, when cottages were being built in Gresley Row (now the Three Spires Shopping Centre), a large quantity of cow bones, horns and skulls were found. These could be the remnants of the massive feast but more probably the remains of industrial activity such as tanning and horn working.

His final visit came two years later, in August 1399, when Richard was kept prisoner in the Cathedral Close after being captured during an uprising led by his cousin, Henry Bolingbroke. He was kept in Lichfield while in the process of being moved to the Tower of London. According to some sources, Richard attempted, unsuccessfully, to escape from the north-east tower of the fortified Close by using a rope to clamber down the wall.

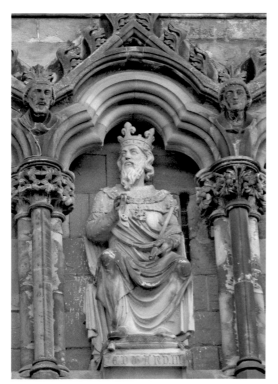 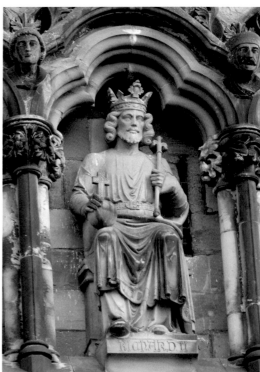

Above left: Statue of Edward III on the west front, holding the royal sceptre in his left hand and a garter in his right, signifying the Order of the Garter, which he founded.

Above right: Statue of Richard II on the west front of the cathedral, holding the Imperial Orb and Sceptre.

Below: Left, hidden behind ivy, is the remains of the north-east tower, part of the Close fortifications. The remains of the wall are in the foreground. The Civil War damage has been repaired.

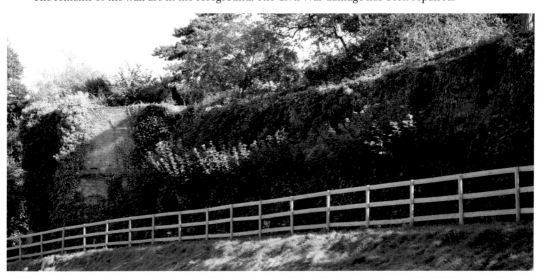

5

Reforma'tion

Reforma'tion n.s. [reformation, Fr. from reform.]
2. The change of religion from the corruptions of popery to its primitive state.
The burden of the reformation lay on Luther's shoulders.
Atterbury.

Serious changes were afoot for the city over the next two centuries. The focus switched from the cathedral and the shrine of St Chad to the city itself. Almshouses and schools were set up. The royal households switched from the Plantagenet family to the Tudors.

Many different trades developed over the years. Stowe Street was full of leather workers and a brickmaker, Robert Bird. Simon the Cobbler had land in 'Gaye in Lichfield' (Gaia Lane). Robert the Tanner had a plot by the causeway on Dam Street. Judging from the leather offcuts found during the 1973 dredging of Minster Pool, Robert the Tanner was a resourceful man. He would repair shoes until they could not be repaired any further and they made use of as much of the leather hide as possible. Beacon Street, due to its proximity to both Cathedral Close and the city, ended up with quite a few brothels. There is a record of a woman who lived on Conduit Street who earnt £3 (equivalent to £2,000 nowadays) because she made herself available to the Duke of Clarence's household when he visited the city. There were plenty of alehouses as well, with the King's Head on Bird Street being founded in 1408.

A private pavilion or washhouse with added garderobe shute (straight into Minster Pool) was built in the gardens south of the cathedral. A 'New College' (residence for chantry chaplains) was established on the site in 1411, 'new' as it was a successor to that of the 'Vicar's Close'. Additions were made to the New College in 1468, which included a bakehouse and a brewhouse. The buildings to either side were those belonging to Canons Hugo Holbach, to the east, and John de Saxon, to the west. The New College was dissolved in 1548.

An almshouse was founded by Bishop Heyworth on Beacon Street in 1424. The accommodation included a small chapel and was to house fifteen poor women. It was re-endowed eighty years later by Thomas Milley, one of the cathedral canons, and it now bears his name. The rental custom, revived in 1987, was that the bishop was to receive one red rose from each resident on 24 June, St John the Baptist's day.

The Hospital of St John the Baptist Without the Barrs was rebuilt as an almshouse in 1495 by Bishop Smyth. Accommodation was given to thirteen almsmen for 7d (3p) per week, and they had to wear a distinctive black gown with a red cross. A school was included as part of the almshouse. Scholars were to be given instruction 'gratis' and that the 'Master of Grammar' had a yearly wage of £10. The following year, the warder of St Leonard's Hospital in Freeford, John Paxson, resigned his wardenship so that the leper hospital could be merged with the Hospital of St John.

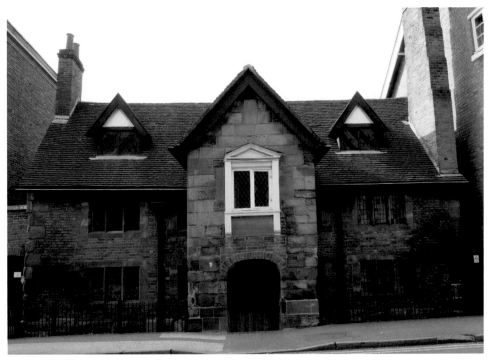

Above: Dr Milley's Hospital on Beacon Street. The door was on the original road level but over time the road increased in height.

Below left: A seal matrix of the Hospital of St John the Baptist Without the Barrs dating to around the 1490s. It was used for official documentation. (Copyright: Lichfield District Council)

Below right: A portrait of William Smyth, Bishop of Lichfield. (Copyright: Lichfield District Council)

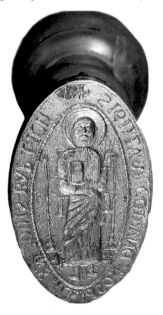
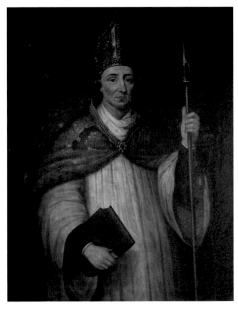

1538 first saw the destruction of St Chad's shrine in the cathedral. The Dudley family took the relics of St Chad into safe-keeping and three centuries later they were donated to Birmingham Cathedral, dedicated to St Chad. Then came the dismantlement of the friary due to Henry VIII's Dissolution of the Monasteries. The Bishop of Dover was commissioned to close the friary and sold the land to Richard Crumblihome, a land speculator. He sold it on to Gregory and Alice Stonyng. Many of the buildings were quickly demolished, but some elements were retained for reuse in a new house, which in later centuries had a formal garden.

Without St Chad's shrine the city forged a new identity by latching onto an old legend. It stated that during the third century AD, Amphibalus, a Christian priest, and his followers were travelling west and ran into Diocletian, the Roman Emperor, and his army. A battle ensued with the unfortunate result of all Amphibalus's men being slaughtered. One version included three murdered Anglo-Saxon kings. The dead were buried at Christian Fields, now a housing estate off Eastern Avenue. The origin of the

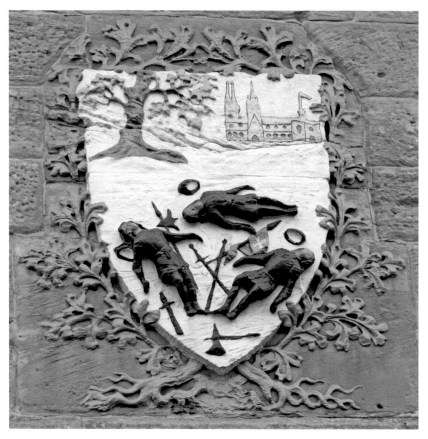

The coat of arms for the City Corporation of Lichfield on the railway bridge, dating from 1882. On the north side of the bridge, the two upper shields are for the City of Lichfield, and the Arms of England. Below those are four shields representing four bishops: Hackett, de Clinton, Lonsdale and Hayworth. On the south side are four shields representing local families: Anson, Forster, Dyott and Bagot.

name Lichfield was amended to mean the field of the dead in Latin. A new coat of arms was created to include the cathedral, a tree and three murdered kings.

After the friary was dissolved, a townsman, Hector Beane, bought the lands that the conduits ran through and gave them to the city as part of a charitable gift. This donation formed the Conduit Land Trust, founded on 3 January 1545. The Trust continues to benefit the city today, with a prime purpose to maintain the water supply to the town by the leaden conduit from the springs at Aldershaw. The Trust assisted with sanitation, lighting, fire prevention, education, and relief of the poor.

In 1548, Edward VI granted the city a charter, which meant that it would be governed by two bailiffs (chosen annually) and twenty-four burgesses. Prior to this, the city was governed by the Bishop via a Manor Court, although the Guild of St Mary and St John the Baptist (founded in 1387) had an increasing voice in the governance of Lichfield. In 1553, a new charter by Mary I gave Lichfield county status and allowed the city to appoint a sheriff. As part of this charter, the sheriff had to 'perambulate' the city boundaries each year on 12 September, the Feast of the Blessed Virgin Mary. This continues today as the Sheriff's Ride, but by car instead of on horseback.

During the five years of Mary I's reign, nearly 300 people across the country were burnt at the stake for refusing to give up Protestantism in favour of Catholicism. Three of those were executed in the market place in front of St Mary's Church. They were Joyce Lewis, John Goreway and Thomas Hayward. The men were burnt in 1555

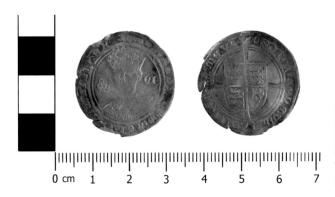

Sixpence of Edward VI (WMID-DDB55B), minted in London and found nearby in Staffordshire. (Copyright: The Portable Antiquities Scheme)

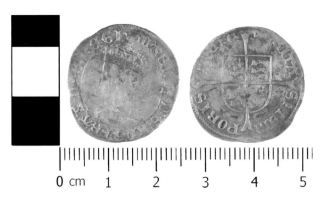

Groat of Mary I (WMID-085612), minted in London and found close to Lichfield. (Copyright: The Portable Antiquities Scheme)

and Joyce Lewis two years later. Born a Catholic, she converted to Protestantism after witnessing the execution of Lawrence Saunders in Coventry in 1555 as he was burnt alive. Her husband, Thomas Lewis, was a Catholic and tried to persuade her to change her mind. Joyce turned her back on the altar, which was enough to get her arrested and imprisoned in the cathedral prison. She spent a year in jail before her sentence was carried out on 18 December 1557.

The church prison was close to the consistory court on the south side of the cathedral, towards its east end. There are three small vaults beneath the small chapels on the south side of the choir, reached by an external door. They can be seen beneath the level of the lady chapel, in a tunnel crypt, divided into three, all with stone floors. Each cell has a narrow, unglazed double window. The bottom of each window is at ground level outside. They were built because the lady chapel was built on land that slopes steeply away to the south, so the floor on the south side had to be raised to keep it level.

Ecclesiastical courts exerted control over a wide range of different case types, such as probate, tithe, faculty and matrimonial. These courts passed judgement on various kinds of moral matters such as fornication, defamation and clergy discipline, often earning the nickname of 'bawdy' courts. The north transept of the cathedral would be turned over to the consistory court on a fortnightly basis, until the end of the eighteenth century, when it moved to the old vestry. To be tried at a consistory court, the cases had to have arisen in the parishes under the bishop's control. A peculiar court covered areas that fell outside of the bishop's authority. The types of cases brought to the consistory court included those brought by

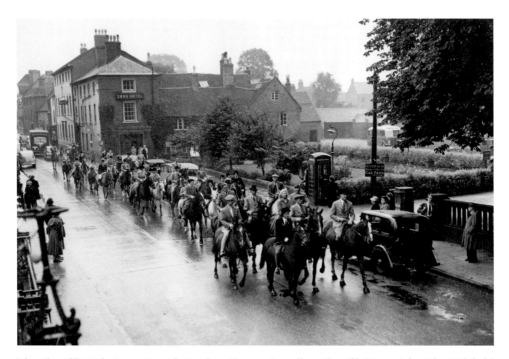

The Sheriff's Ride in 1958, with Gordon Clayton Powell as Sheriff. (Copyright: The Lichfield St Mary's Photographic Collection)

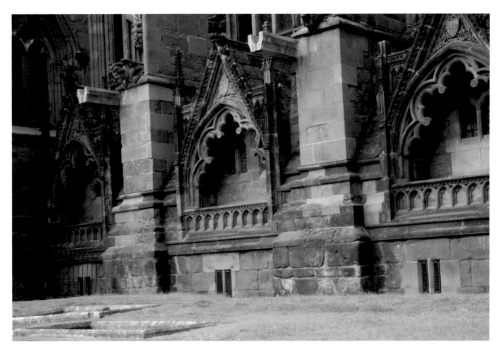

Just above ground level are three windows belonging to the cathedral prison cells. A vaulted basement is beneath the south choir, split into three.

the office of the bishop, often involving moral offences, disobedience, and non-attendance at church. Then those brought 'at the instance' of a private person, a civil matter. This included matrimony, defamation and probate. The final type, the 'office promoted' cases, were brought by a private individual who had to reimburse the bishop should the case fail. Punishments included penances, suspension and even excommunication from the church.

By 1561, the Guild of Corvisors (Shoemakers) was set up, to prevent untrained individuals from arriving in town and setting up shop. The guild required that a seven-year apprenticeship had to be served and no more than two apprentices per master. If an individual failed to do that, they were unable to buy or sell leather within the city or practise as a master shoemaker or currier. The only exemption was made if they paid £10 for the privilege. Guild members were not allowed to entice away a fellow member's employees or to pay journeymen more than an agreed fixed price for various types of shoes. A dozen plain shoes were worth two shillings (approximately £25 today).

Religious persecution continued during the reign of Elizabeth I, but this time against Catholics instead of Protestants. Under the new restrictions, Catholics were not allowed to celebrate Mass. This was done to stop Catholic sympathisers from plotting to restore a Catholic monarch to the throne. Despite it becoming illegal to practice Catholicism, a way was found thanks to a Jesuit priest, Nicholas Owen, and his master, Father Garnet. He spent most of his life constructing 'priests' holes' in stately houses. The priests' holes were hiding places where a priest could take refuge should 'pursuivants' (priest hunters) come in search of illegal Catholic Masses being performed. Most priests' holes could be a subterranean

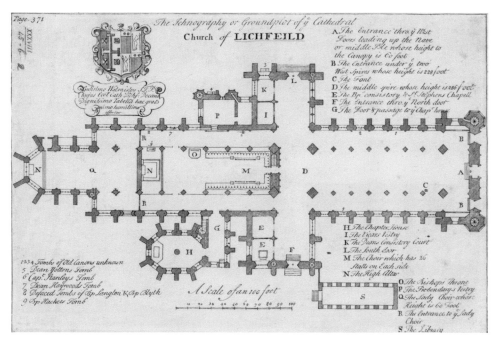

Above: This eighteenth-century plan of the cathedral marks 'K' as the location for the dean's consistory court. This is now the regimental chapel. The location of the consistory court did change over the centuries. (Copyright: British Library)

Below: The priest hole at Tudor of Lichfield. Left: the door and graffiti (date added later). Middle: the entrance into the priest hole. Right: inside the priest hole.

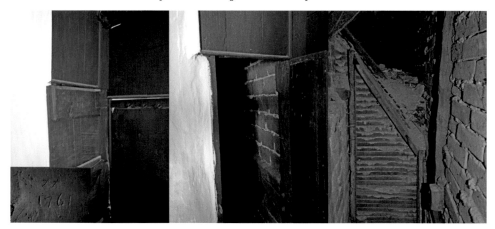

passage, or hidden between walls, or under the floorboards, or even behind chimneys, like on the top floor of the Tudor of Lichfield on Bore Street. Hidden by a concealed door is a void behind the chimney breast, big enough for someone to hide inside.

Edmund Gennings was born in Lichfield in 1567. At sixteen, he became Richard Sherwood's page and followed his master's footsteps, becoming a Catholic priest.

Returning to Lichfield in 1590, he discovered that his family were Protestant and only one of his brothers lived. This brother had moved to London, so Edmund travelled down. In November 1591, while saying Mass with Polydore Plasden, a fellow missionary, their house was raided by enforcement officers. Both Edmund and Polydore were found guilty of treason and sentenced to be hanged, drawn and quartered. Edmund's final words, a prayer to St Gregory, enraged the executioner, who cut him down from the noose before he was stunned by the hanging, so he had to endure the pain of drawing and quartering. On witnessing the execution, Edmund's brother converted to Catholicism.

In 1571 and 1575, the Clerk of the Worshipful Company of Goldsmiths compiled a list of Freemen living out of London, stating that John Gladwyn and Nicholas Collyns were living in Lichfield. Lombard Street, named after Lombard Street in London, where goldsmiths from Lombardy in France settled, provides a modern reminder of these two goldsmiths.

During July 1575, Elizabeth I continued her 'progress' around the country and stayed in Lichfield for a week. Great preparations were made for her visit, including paving the market place, repairing the market cross and refurbishing the Guildhall. Improvements were made to the road leading out of the city to the south. A payment made to the Earl of Warwick's Players suggests that part of the entertainment was a play.

In 1577, the school at the Hospital of St John moved across the road and became the Lichfield Grammar School.

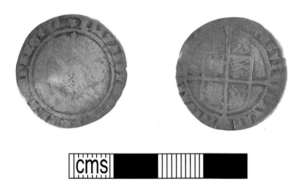

Left: A sixpence of Elizabeth I dated to 1575, minted in London and found on the outskirts of Lichfield (WMID-593EF3). (Copyright: The Portable Antiquities Scheme)

Below: The Lichfield Grammar School occupied both buildings close to each other on St John Street. The building on the right now functions as the Council Chambers of Lichfield District Council.

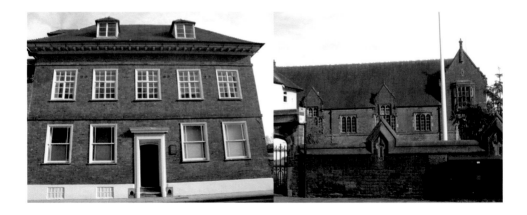

6

Rebe'llion

Rebe'llion n.s. [rebellion, Fr. rebellio, Lat. from rebel.] Insurrection against lawful authority.
He was victorious in rebellions and seditions of people.
Bac.

James VI of Scotland succeeded to the English throne after Elizabeth I (his first cousin twice removed) died in 1603, starting the Stuart dynasty as James I of England. He was a much stricter Protestant than his predecessor, believing in the Divine Right of Kings. This belief caused nationwide chaos in the form of Civil War, as the country split in two, those loyal to the King and those loyal to Parliament. It saw soldiers take to the streets in the city and fight over the fortified cathedral close. The aftermath of the war saw damages repaired and the cathedral rebuilt.

Several water conduits were set up around town, the Crucifix conduit at the friary gate, the Butcher's Row conduit (outside Boots on Tamworth Street), the Stone Cross conduit at the junction between Lombard Street and Tamworth Street, and the Cross conduit in the market place. Each conduit was frequently visited as a source of clean drinking water, the scene of many quarrels and a great gossiping spot. To discourage people from holding wash days at them, two 'washing places' at Sandford Bridge and the Bishop's Mill were established.

Edward Wightman was the last person to be burnt alive for heresy in the market place, on 11 April 1612. Rising in popularity in Puritan circles since the 1590s, Edward gradually became more radical, eventually taking on the beliefs of an Anabaptist. He declared he was the prophet, he denounced the Holy Trinity and claimed that Christ was only a man. He told James I that he, Edward, was the Messiah and the only route to speak to God was through him. Edward was arrested in 1611 by Richard Neile, Bishop of Lichfield. Over 500 people attended the trial in November 1611, which had to move from the Consistory Court to the lady chapel. He was found guilty of sixteen cases of Heresy and held in the cathedral cells until his execution on 20 March 1612, where he was taken to the market place and secured onto a pyre. Soon after the fire was lit, Edward called out that he would recant his beliefs. The watching crowd was much relieved; some helped to extinguish the flames and got badly burnt. He returned to gaol and was brought back to the consistory court three weeks later, where he refused to recant his beliefs. He was returned to the market place and placed on top of a second pyre of wood. This time no second chance was given as he tried to change his mind before being burnt alive.

Lady Eleanor Davies, a poet, self-styled prophet, and religious activist, expressed her views in the city. Her first pamphlet, 'A Warning to the Dragon and All His Angels', compared the Bible's Book of Daniel to contemporary events. During her life, she wrote sixty-nine

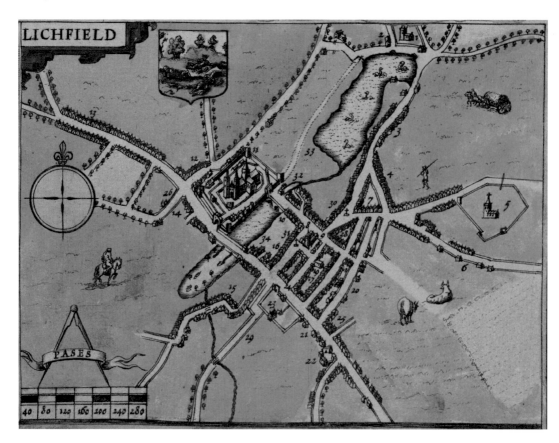

Detail from John Speed's 1610 Map of Staffordshire. Nos 9 and 24 on the map are two conduits. The other locations are: 1 = Stowe Church (now St Chad's Church); 2 = Stowe Mill; 3 = Stowe Street; 4 = Loyles Lane; 5 = St Michael's Church; 6 = Rotten Rowe; 7 = Tamworth Street; 8 = The Chappell (now St Mary's Church); 10 = Dams Street; 11 = St Chad's Minster (cathedral); 12 = Layes lane; 13 = Bacon Street; 14 = Almshouse (Dr Milley's Almshouse); 15 = Samford Street; 16 = Sadlers Street; 17 = Bore Street; 18 = Wade Street; 19 = Towne Hall (Guild Hall); 20 = Frogge Lane; 21 = St Johns Street; 22 = St John's Hospital; 23 = friary; 25 = Free Schole; 26 = Grey Marger Lane; 27 = Greenehill Street; 28 = Friers Lane; 30 = High Cross; 31 = Stowe Crosse; 32 = Damm Mill; 33 = Stowe Mere (Stowe Pool); 34 = Damm Mere (Minster Pool). (Reproduced by kind permission of the Syndics of Cambridge University Library)

prophecies. She was arrested after she was caught smuggling illegally printed copies of her prophecies into England. She was released in 1637 and was promptly imprisoned again because she poured tar over the altar in the cathedral. This time she was sent to Bedlam, the prison for the mentally ill. She died in 1652 after being released from prison.

The city corporation was reorganised in 1622 following a charter issued by James I. It reduced the number of brethren running the corporation down to twenty-one. Bailiffs were to be drawn from the brethren and the Senior Bailiff chosen by the Bishop. The charter was reissued a year later in 1623 and enabled the independence of the Cathedral Close.

Civil War was declared across the country on 22 August 1642, as Charles I raised his standard at Nottingham. Charles used the Commissions of Array to help raise troops to support his cause. This report required those to whom the letter was addressed to hold musters, view arms and report findings back to the King. Troops were raised in Lichfield for the King's cause by Lord Paget of Beaudesert and Sir Richard Dyott. However, the Corporation of Lichfield found in favour of the Parliamentary cause.

The North, Wales, the Borders, and the West Country favoured the Royalists, whereas London, the Eastern Counties, Derbyshire and the South East were on the opposing side. Staffordshire and Lichfield fell into the borders between the two factions. The Close fortifications built by Bishop Langton created the perfect stronghold, and who held the Close-controlled Lichfield and communications north and south.

In January 1643, the Royalist leaders commanded by the Earl of Chesterfield moved into the Close. The gates were shut and a red flag raised on the central tower of the cathedral, declaring Lichfield was held on behalf of the Royalist cause. This news was carried to the headquarters of the Earl of Essex who instructed Robert Greville, 2nd Lord Brooke to take the Royalist stronghold.

Detail from Speed's map annotated with the features of the first siege. Red is for the King's Men, orange for Parliament. (Copyright: Cambridge University Library)

Lord Brooke had a force of 1,200 men, 'Black Bess', a demi-culverin (type of cannon) and several drakes (small cannons). They entered Lichfield on 1 March and took over the town, with their headquarters being on Sadler Street. The offensive was launched against the south gate, with troops lined up along Dam Street and by the side of Minster Pool. Black Bess was positioned just south of the causeway leading to the south gate, within musket range from the Close. Bombardment began on 2 March, St Chad's Day. John Dyott and another Royalist sniper took up position on the cathedral tower. Lord Brooke, in a purple tunic, was their target and when he came to survey the troops, they took aim, killing him outright as he was shot in his left eye. The Royalist troops celebrated as they viewed this triumph be a sure sign of their impending victory.

Lieutenant Colonel Sir Edward Peyto was now in command of the Parliamentary troops and kept the news of Lord Brooke's death as quiet as possible, spreading a rumour that his servant died instead. News was sent to Sir John Gell, Governor of Derby, with a request for help. The Parliamentary soldiers destroyed the market cross, adorned by crucifixes and statues of the apostles, and St Chad's Church was damaged by the troops lodging there.

Under Peyto's command, wives and relatives of the Royalist commanders inside the Close were rounded up and kept under armed guard. These civilians were to be used as human shields to enable the attackers to get close to the south gate to break it down. The defenders within the Close saw the approach and opened fire on the advancing troops, aiming to avoid the civilians. The attackers withdrew and the civilians were allowed to return home. Peyto was wounded in this skirmish.

Colonel Henry Hastings, in Ashby-de-la-Zouch, received news of the siege and came to help the Earl of Chesterfield. The relieving troops were split in two. One entered to the northwest via Beacon Street and the other to the southwest, via St John Street. After causing a satisfactory number of casualties, Hastings withdrew and returned to Rushall.

Sir John Gell arrived in Lichfield on 3 March, restoring the morale of the Parliamentarian troops and reinforcements from Colonel Sir William Brereton and Lieutenant Colonel Simon Rudgeley. Flammable materials and long ladders were rounded up from the city. An assault was launched again against the south gate, which failed due to the Royalist troops lowering the drawbridge and making a surprise attack. The ladders were used to try and attack the close from Gaia Lane; however, the sentries on the cathedral tower spotted what was happening and organised an ambush for the unsuspecting Roundhead soldiers.

The Parliamentary soldiers withdrew until a mortar (very large cannon) arrived from Coventry on 4 March. A mortar used 10-inch-diameter iron balls as projectiles. These iron balls were hollow and would be packed with gunpowder, which would explode and shatter on impact. The mortar was positioned on the edge of Minster Pool, in the garden of Sir Richard Dyott's house on Sadler Street. The targets were the prebendaries and canons' houses on the south side of the Close, with both property and physiological damage. Lord Chesterfield was encouraged to surrender by other occupants of the Close and supplies were running low, so the Royalist red flag was lowered on 5 March, and terms were drawn up for the surrender and the end of the first siege.

Lieutenant Colonel Russell's Parliamentary troops entered the Close and proceeded to strengthen the fortifications and an organised destruction of the cathedral furnishings. Statues were pulled down or used as target practice. Stained-glass windows were smashed and organs taken apart. The books in the library were burnt, apart from the St Chad's Gospels, which had been taken to safety prior to the siege by Prebendary William Higgins.

Just over three weeks later, on 27 March, Prince Rupert received instructions to retake the city for the Royalist cause. He arrived on 6 April. Scouts were sent ahead for reconnaissance and a decision was made to mount his attack from the north. Fortifications were built – 'Prince Rupert's Mount' – to hold the artillery.

The attack was launched in the early morning of 8 April, with the artillery aimed against the north walls of the Close to make a breach through which an attack could be made. This approach proved unsuccessful, so a different tactic was employed. Fifty miners from Cannock Chase were recruited to dig tunnels to undermine the walls. The defenders worked out what was happening, so they started to dig countermine tunnels to intercept the tunnellers.

On 16 April, one Royalist tunnel broke through into a countermined tunnel, and a brief underground fight ensued until the decision was made to withdraw on both sides and to abandon the tunnel. Two other tunnels were discovered and likewise abandoned. The fourth tunnel was more successful as it reached the foundations of the northwest tower.

Four days later, on 20 April, the Royalists launched their attack. Under the cover of darkness positions had been taken up with scaling ladders all around the walls. Then as dawn rose, the fuse was lit to ignite the five barrels of gunpowder underneath the northwest tower. A hole wide enough for six men to march abreast was blown in the Close walls. The Parliamentary soldiers tried to repel the incoming troops with hand grenadoes (handheld mortars) and a fierce battle ensued resulting in causalities on both

Prince Rupert's Mount, situated to the north of the Cathedral Close, off Prince Ruperts Mews.

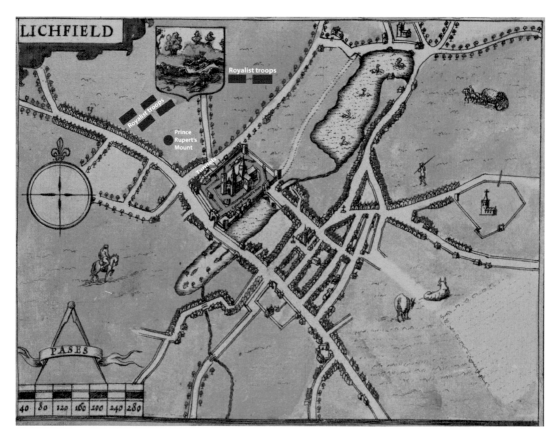

Detail from Speed's map annotated with the siege fortifications of the second siege (Copyright: Cambridge University Library)

sides. On the Royalist side, three commanders (Colonel Gerrard, Wagstaffe and Lord Digby) were wounded, and Colonel Usher was killed. Prince Rupert was shot in the foot and 120 Royalist soldiers were taken prisoner. On Parliament's side, only fourteen were killed before the Royalists retreated.

This fight used up most of the gunpowder supplies held within the Close, so their artillery was useless, and food was in short supply. Colonel Russel had no choice but to surrender and Prince Rupert accepted, with Colonel Hastings drawing up the terms.

Colonel Hastings allowed Colonel Russel and his men to march out of the Close with eleven closed wagons containing bags, baggage and probably the cathedral plate. Colonel Bagott, of Blithfield, was appointed Governor of Lichfield Close and held it for three years in relative peace before the final siege happened in 1646.

Queen Henrietta Maria visited in July 1643 on her way from Ashby-de-la-Zouch to Stratford-on-Avon where she met Prince Rupert. She brought over 1,000 mounted dragoons, twenty drummers, 2,000 musketeers, six pieces of artillery and 150 wagons of arms and supplies. Two years later, after the Parliamentary victory at the Battle of Naseby, Charles I retreated to Lichfield, spending the night in the former Bishop's Palace, before

moving to Wolverhampton. The Battle of Naseby in 1645 marked a turning point as the organised military might of Parliament and the New Model Army was superior to the troops fielded by the Royalist cause.

The Duke of York pub on Church Street was founded in 1644. Plague hit the city in July 1645, beginning at two of the principal inns of the city and spreading quickly. However the Close remained mostly plague free. In total a quarter of the population, 800 people, died.

The third and final siege started on 9 March 1646, with Sir William Brereton's Parliamentary troops' arrival. Sir Thomas Tyldesley oversaw the Royalist garrison, and he withdrew troops from the city into the Close. Preparations had been made to endure a long siege and fortifications strengthened. Brereton decided to surround the Close with earthwork embankments to keep both the Royalists in and to defend his troops. A trench ran from Stowe Pool to Beacon Street and another from Beacon Street to the Bishop's Pool. Mounds were built at each end and a third one, nicknamed 'Gloucester mount', to the north of the Close. A fourth mount was built on Dam Street, facing the south gate.

From the cathedral tower, Tyldesley saw what was happening and organised small attacks to harry and hinder the Parliamentary troops. Houses were burnt down along

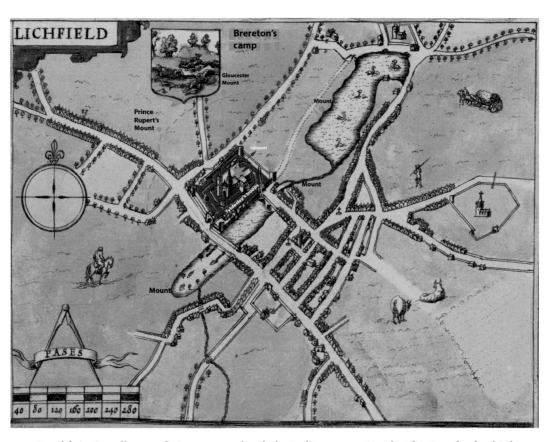

Detail from Speed's map of 1610, annotated with the Parliamentary siege fortifications for the third siege. (Copyright: Cambridge University Press)

This Pikeman's helmet, commonly known as a 'morion', was typically worn by members of Parliament's New Model Army. (Copyright: Lichfield District Council)

Beacon Street near to the west gate to prevent them from providing cover to the attacking forces. A trench was built leaving the garden of the Bishop's Palace, under the east wall and then turning north towards Gaia Lane.

The choice of the Royalists to celebrate the May Fair enraged the attacking Parliamentarians. Heavy artillery was placed on Dam Street mount and targeted the central tower. At eleven o'clock on 12 May, a cannonball struck the base of the spire, sending the whole structure crashing to the ground. The morale of the Royalists troops was lowered but they refused to surrender.

On 26 May, Brereton rounded up eight women and children who had husbands in the Close. They were assembled on Bird Street and forced to march up to the causeway in front of the West gate, under the pain of death if they tried to turn back. Tyldesley had a dilemma. Take mercy on the wives and children and let them into the Close and become additional mouths to feed inside, and risk them bringing the plague in, or leave them out in the cold? The decision was made not to admit them, and they were forced to spend the night without any shelter. More women were rounded up by 28 May. Their final fate goes unrecorded, but the Close continued to hold on until 10 July when, as one of the last Royalist strongholds, it was surrendered to the Parliamentary troops.

Tyldesley marched his troops out of the Close as part of the surrender agreement on 16 July with their banners flying. Then the Parliamentary troops slighted the fortifications to prevent it from being used as a stronghold again. The Close walls were razed to the ground, with only towers remaining in the northeast and southwest. The gateways remained but the portcullises and the wooden gates were removed. St Chad's Church in Stowe was badly damaged by lead removed from the roof by troops that were billeted there.

Within the city, temporary gaols were created to house prisoners, like the cellars of the Tudor of Lichfield on Bore Street. Large metal rings were secured to the wall and large sturdy wooden doors added. Some of the inhabitants left a reminder of their presence there in the form of carved graffiti signatures and initials on the cellar doors,

Right: The southwest tower of the Close fortifications survives as part of St Mary's House on Reeve Lane.

Below left: The remains of the west gate in the Close.

Below right: An iron ring that was used to shackle prisoners in the cellars of The Tudor of Lichfield, Bore Street.

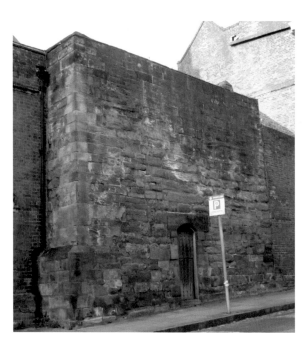

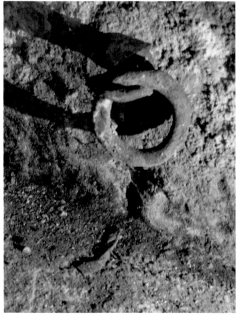

like John Hampden after the first siege. Hampden, along with four other men – Pym, Haselrigg, Hollis and Strode – denied Charles I's attempt to raise funds illegally by trying to impose 'Ship Money' taxes. The Tudor's cellar was used during all three sieges.

Squatters moved into the Close to occupy the cathedral ruins and the houses, including two pipe-maker families, Johnson and Gunson. Clay tobacco pipe fragments were found when excavations were carried out underneath the Bishop's Palace in 1869. These dated from between 1640 and 1680, some made in Broseley, Shropshire, and others more local.

George Fox, a travelling preacher and founder of the Society of Friends (Quakers), was released after several months in prison for blasphemy in Derby. He resumed his travels on release and experienced a vision upon seeing the distant spires of Lichfield Cathedral. This vision saw the city surrounded by a pool of blood. He felt he had to warn the residents of his vision and walked into the city barefoot, leaving his shoes with some shepherds. On arrival, he trudged the streets and the market place, crying out 'Woe to the bloody city of Lichfield' as he was guided by the Lord. Unlike those in Derby, the authorities left him in peace and Fox left Lichfield to retrieve his shoes from the shepherds.

Following the Restoration of the Monarchy in 1660, there was a shortage of halfpennies and farthings as they were not issued by the Royal Mint. These coins were needed as change or for alms for the poor. Trade tokens, issued by corporations and traders, appeared to address this shortage. There were eight different trade tokens issued in Lichfield, one by the City of Lichfield and the rest by traders: Edward Milward, a bookseller; Josiah Mosse of the Ironmonger's arms; Thomas Catterbanke; John Burnes; Thomas Minors; Humphrey Rogerson; and John Quinton of the Mercer's Arms. These tokens stopped being used in 1672, as official halfpennies and farthings were struck by the Royal Mint again.

Bishop Accepted Frewen returned to his position as Bishop when Charles II restored the bishopric after the Commonwealth. John Hackett succeeded him after less than a year. He restored some of the damage done to the cathedral during the three sieges. A statue

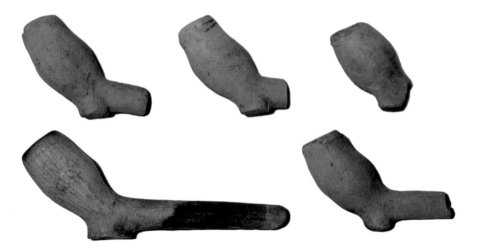

Clay pipe bowls recovered from the excavations beneath the Bishop's Palace, Lichfield, in 1869. All have a rouletted rim and a circular heel at the base. (Copyright: Lichfield District Council)

Right: An oil painting titled *Woe to the Bloody City of Lichfield* by Robert Spence, depicting George Fox walking barefoot and proclaiming. The ruined cathedral tower is in the background. It is on display in the Hub at St Mary's Church. (Copyright: Lichfield District Council)

Below: Four of the eight different trade tokens that were issued in Lichfield. Top row, halfpennies; bottom row, farthings. *Top left*: John Burnes of the Mercer's Arms. (LVPL888, Copyright: Portable Antiquities Scheme) *Top right*: Edward Milward of the Stationers' Arms. (Copyright: Lichfield District Council) *Bottom left*: Thomas Minors, Member of Parliament. (WMID-D99651, Copyright: The Portable Antiquities Scheme) *Bottom right*: John Quinton of The Mercer's Arms. (WMID-4E0827, Copyright: Portable Antiquities Scheme)

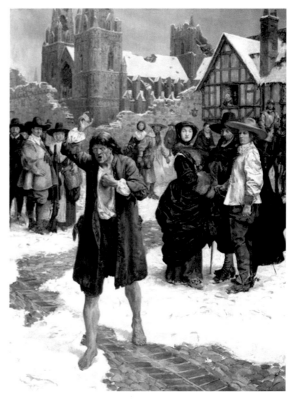

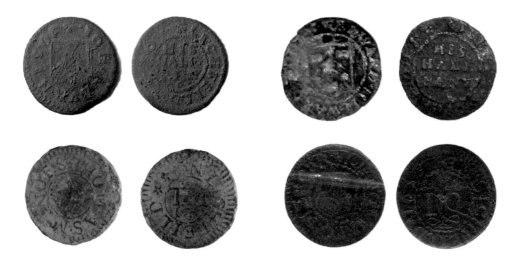

of Charles II was erected on the apex on the west front following a donation of 100 oaks from Cannock Chase for the rebuilding. The statue remained until later alterations moved him to outside the south door. Once the library was restored, Frances, Duchess of Somerset returned the books and manuscripts that had been hidden prior to the looting of the cathedral, including the St Chad's Gospels.

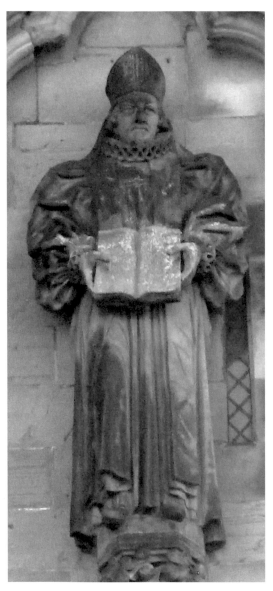

Left: Statue of Bishop Hackett on the west front, holding a copy of the Bible.

Above: A seventeenth-century seal matrix belonging to the dean and chapter of the cathedral. The date inscribed on it, 1661, marks the year that Bishop Hackett was appointed and the start of the reconstruction of the cathedral following the slighting during the Civil War. The matrix depicts a plain cross with a St Chad's cross in each quarter. (Copyright: Lichfield District Council)

Hackett built his residence where the 'New College' had been, south of the cathedral, with a banqueting hall. His successor, Wood, commissioned architect Edward Pierce to build a new Bishop's Palace in a classical style to the north. The wings were a later addition. Wood rented out the Bishop's Palace as he preferred to live at Eccleshall Castle. Many later bishops continued this trend of renting out the palace.

Thomas Minors was a member of Parliament for Lichfield during the period of the Commonwealth and endowed the Presbyterian English Free School in Bore Street in 1670, so that thirty poor boys could be taught to read the Bible in English. He died seven years later. The grammar school on St Johns Street gained a new schoolmaster's house

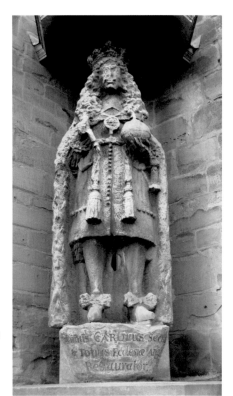

Right: The Statue of Charles II, now positioned to the side of the south door of the cathedral.

Below: The Bishop's Palace, now part of the Lichfield Cathedral School.

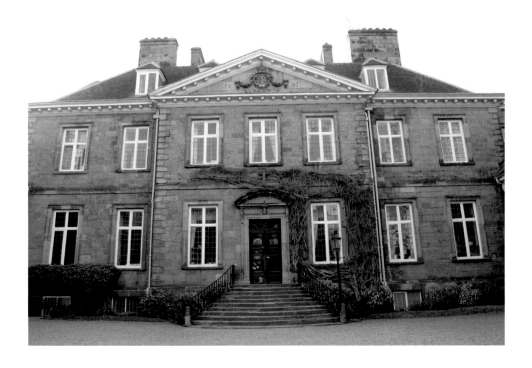

This engraving depicts a racecourse at Brighthelmstone, Sussex, in 1790 but a similar scene would have been seen at the Lichfield Races. (Copyright: The British Library)

in 1682, as the previous one had been significantly neglected. Just before the end of the seventeenth century, the grammar school statutes were amended and the one related to free education was taken out. This meant that the grammar school started to charge a 'reasonable allowance for the teaching of children'.

A racecourse was created on Fradley Common. It was an oval course of around 2 miles, with another one of 5 furlough lengths for sprints. The first race was on Saturday 15 October 1678. These races were supported by the city, with the winner being awarded a cup, the 'City Plate', by the Corporation.

7

Enli'ghten

Enli'ghten v.a. [from light.]
2. To instruct; to furnish with increase of knowledge.
This doctrine is so agreeable to reason, that we meet with it in the writings of the enlightened heathens.
Spectator.

The eighteenth century saw Lichfield blossom as a coaching centre and emerge as the 'City of Philosophers'. Transportation relied on horses, with travellers either riding horseback or using horse-drawn carts. Coaches were used from 1660, with the main peak of their use being from 1750 onwards. The races brought more tourists and visitors to the city, and the Cathedral Close became a fashionable place to live.

The first decade of this century saw the relocation of the Lichfield races to Whittington Heath, where they remained until 1895, and the founding of the 38th Regiment of Foot at the King's Head pub, later renamed as the South Staffordshire Regiment. Their dedicated chapel is in the cathedral. Samuel Johnson was born in Lichfield in 1709 and christened at St Mary's Church within a few days of birth as he was a sickly child and not expected to survive.

As Lichfield was located centrally on the main roads between London, the North, Chester and Liverpool, it meant that national coaches would call daily. Sheffield, Manchester, Derby and Birmingham all had local services and several coaching inns still survive: The George Hotel, The King's Head and the Swan Hotel. By 1732, there were eighty inns and taverns and many beer houses that only sold ale.

With increased coach traffic, decent roads were required and so the Lichfield Turnpike trust was set up in 1729, covering most of Staffordshire. When an individual passed through a turnpike, a toll was charged. The value was dependent on the size of the vehicle, so for a coach drawn by six horses, the charge was 6d. For a single horse, it was 1d. The toll charge was used to maintain the roads.

The Lichfield races initially competed against several others within Staffordshire – Burton, Stafford, Tamworth, Stone, Newcastle, Eccleshall and Penkridge – but quickly they became the favoured venue. Races were held twice a year: three days in the spring for steeple chasing and then three days in the autumn for flat racing. Other activities, such as greyhound racing, cock fighting and evening balls, were also put on. At its height, the race meeting would attract thousands of people from all over the Midlands. A large grandstand was erected to cater for all of them; this was the club house for the Whittington Golf Club.

Dame schools established in the previous century carried on educating the poor. Samuel Johnson attended one on Dam Street, his teacher being Ann Oliver. For older

A map showing the different Turnpike Trusts and routes around Lichfield. (Key: Blue = Burton to Alrewas and Stenstone. Red = Coleshill to Stone (First Lichfield District). Black = Tamworth. Yellow = Castle Bromwich to Birmingham. Orange = Burton to Abbot's Bromley. Brown = Newport to Stonnall. Green = Featherbed Lane to Kings Bromley. (Copyright: Ordnance Survey)

children, there was the Minors School for Boys and the grammar school at St John the Baptist Hospital. The grammar school had several notable pupils including David Garrick and Samuel Johnson. Johnson moved to London with Garrick and wrote *A Dictionary of the English Language* in 1755, which was heralded as being amongst the greatest achievements of scholarship. The dictionary took over nine years to write and included entries for 42,000 words. Garrick became a popular actor who revived Shakespeare's plays and brought them to contemporary audiences.

The gaol was housed in the Guildhall, which had fallen into disrepair, but over the century it was rebuilt. The Martyrs' Plaque (now in Beacon Park), representing the City Seal, was placed on the front of the Guildhall in 1744. The gaol saw regular use but was rarely full. A survey in 1771 by John Howard stated that the cells were too small and close and there was no yard, water or straw. Some of the inhabitants included Thomas Orton in 1759, who was gaoled for stealing sheep and lamb and was executed by hanging. However, a few years later, John Bird, who stole some mutton, was only publicly whipped. John Heacock stole a shirt and silk handkerchief in 1764 and was transported to the colonies. Three highwaymen were imprisoned: William Cobb, James MacDonald and William Elliott. Their punishments were either execution or transportation.

The large grandstand building built as the clubhouse for the Lichfield Races, later reused as an Old Soldier's Home for the Staffordshire Regiment and then as clubhouse for the Whittington Golf Club. It has been demolished to make way for HS2. (Copyright: The Lichfield St Mary's Photographic Collection)

The Bishops of Lichfield preferred to live at Eccleshall Castle; therefore, they rented out the Bishop's Palace to private individuals, like Gilbert Walmisley, a good friend of Samuel Johnson. David Garrick did his first performance on the dining table of the palace for Walmisley and his guests. After Walmisley moved out, Dean Seward and his family moved in. His eldest daughter, Anna Seward, took over the lease when he died. She was a Romantic poet who penned many elegies and sonatas. She socialised with the members of the Lunar Society, but was not an official member. She was the driving force behind the landscaping of Minster Pool into a serpentine shape.

Erasmus Darwin, a founder of the Lunar society, moved to the Close in 1756 where he started his medical practice. He was a polymath, with many other interests and specialisms. He studied natural science and wrote the book *Zoonomia*, which laid the groundwork for his grandson, Charles Darwin, to build on for his book *On the Origin of Species*.

The Lunar Society was founded in 1775 by Darwin with Matthew Boulton, James Watt, Joseph Priestley and Josiah Wedgwood being the original members and more people joining them over time. It gained its name since they met on the day of the full moon. During these meetings they would enjoy lunch, discuss ideas and inventions throughout the afternoon and travel home under the light of the full moon. This society helped fuel the Industrial Revolution until 1813.

The Murder Act was passed in 1752, which allowed a felon's body to be used by physicians for study and dissection. Ten years later, after acceptance into the Royal Society, Darwin was able to set up his own anatomy lectures. He acquired the body of a felon, Thomas Williams, who was imprisoned in the gaol in October 1761 for murder and sentenced to execution by hanging. Lectures were held daily at 4 p.m., starting on Tuesday for as long as the body could be preserved.

Selwyn House was built after 1766 for the Canon Reverend Dr James Falconer. The actual date of construction is uncertain; it is absent from the 1766 Conduit Trust Lands Map, but is noted on Snape's map of 1781. The house was built against the Close fortification, predominately inside the outer 'dimble' or ditch. It was three storeys tall and remained in the Falconer family's possession until 1824. Local legend says that the third storey was built by the third spinster Aston sister to block her sisters' view of the cathedral from Stowe House and Stowe Hill House. There is no evidence that any of the Aston sisters ever lived at Selwyn House (or Falconer House, as it was originally known). When viewed from Stowe House, only the south transept and part of St Chad's chapel are blocked and if viewed from Stowe Hill House, nothing is blocked.

Selwyn House in the Cathedral Close.

Dr Falconer acquired as much of the land between his house and Stowe. He worked on improving the land and with John Saville, planted a botanical garden in The Parchments area. This area was where Michael Johnson, Samuel Johnson's father, had his parchment factory to produce books. Two short-lived bath houses were also built. Both Sir John Floyer and Dr Erasmus Darwin were advocates of the benefits of cold-water bathing and had their own cold-water baths off Abnalls Lane.

The Lichfield Botanical Society was short-lived, active only between 1780 and 1787. The three main members were Dr Erasmus Darwin, Dr Joseph Jackson and Sir Brooke Boothby. A membership invite was extended to John Saville but he opted out.

Playwright George Farquhar set his play *The Beaux' Stratagem* in the George Inn. Farquhar spent plenty of time in Lichfield while working as a recruiting officer for the Army. The plot of his play concerns two young gentlemen, who have fallen on hard times, as they travel through small towns trying to find a rich wife. In 1770, a performance of his other comedy, *The Recruiting Officer*, was performed at the Guildhall.

One of the last slave auctions took place at the Bakers Arm pub, next to the Swan Hotel, on 30 March 1771. The enslaved person to be sold was a young African boy aged between ten and eleven years. He was sold by Mr Heeley from Walsall. The *Birmingham Gazette* advert on 11 November 1770 stated that this boy was well proportioned, and spoke good English, was healthy and fond of labour. At that time, it was a sign of wealth and status to have black servants. Slavery had been popular since the mid-1660s but was starting to go out of favour and eventually it became illegal to trade in enslaved people from 1 May 1807. Several members of the Lunar Society including Josiah Wedgwood and Thomas Day were abolitionists and campaigned for the end of slavery, which finally happened in 1837.

A map was drawn up by Mr Snape of Wishaw in 1781, which detailed the number of houses in both the city and Close. He had 722 houses in the city containing 3,555 people compared to forty-three houses in the Close, with only 216 residents. There were seven tollgates including one at the end of Beacon Street. Michael Johnson's parchment factory was recorded, along with a tannery and a watermill by Stowe Pool. At this point, the city had three annual fairs, including the Bower, and two weekly markets and it was represented by two Members of Parliament.

A series of medallions were produced to commemorate repairs on the cathedral, started in 1788 by James Wyatt. Wyatt was born in Shenstone and came from a family of architects and artists. Wyatt, commissioned by the Cathedral Chapter, built on the repairs that Bishop Hackett started after the Civil War destruction. These medallions show a view of the cathedral from the southwest on the obverse and the city coat of arms on the reverse. Wyatt extended the choir into the lady chapel, past the site of St Chad's shrine. The nave bays were dismantled and rebuilt apart from the ends (to support the west end and the central tower). The central spire was dismantled and rebuilt. This rebuilding was to brace the exterior walls of the cathedral from being pushed out gradually due to the weight of the west end and the central tower. The surviving, heavily weathered medieval statues were coated with Roman cement to protect them.

The sundial to the west of the cathedral was moved from the south doorway to the west end. It was placed in its current position in 1929 after passing into private hands.

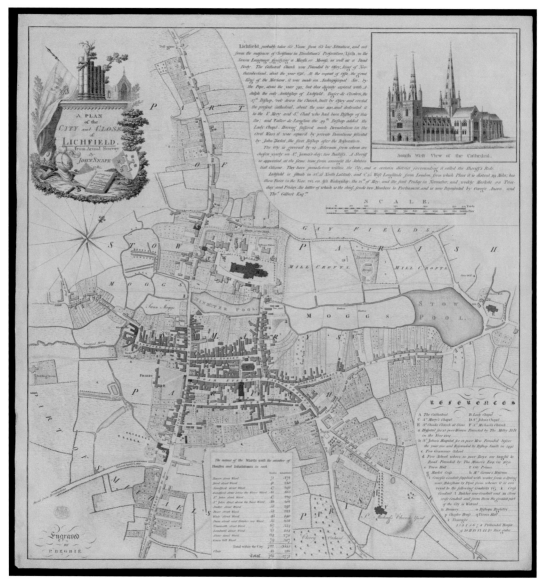

A map of Lichfield, as drawn by Mr Snape of Wishaw in 1781. (Copyright: The British Library)

This sundial is of a cubic design with gnomons on four faces. These faces vary as to whether they show whole hour, half-hour and quarter-hour markings.

Towards the end of the century, there was a shortage of small coin. This was caused by the funnelling of coin into new industrial cities and an increase in counterfeiting. In February 1761, Adam Bell and in 1799 Jane Allen were both sentenced to twelve months' imprisonment for the passing of counterfeit coins. To counteract all the forged coins, local regions issued their own localised promissory tokens. They would be issued to workers instead of wages and told that they would be accepted as payment within the local area.

A commemorative medallion celebrating repairs done to Lichfield Cathedral by James Wyatt. The obverse depicts the cathedral behind trees, S.W. VIEW OF LICHFIELD CATHEDRAL. Beneath, REPAIR'D BY B'P HACKETT IN 1670 & AGAIN BEGAN TO BE REP'D IN 1788. The reverse depicts the city arms, THE ARMS OF THE CITY OF LICHFIELD 1799. (Copyright: Lichfield District Council)

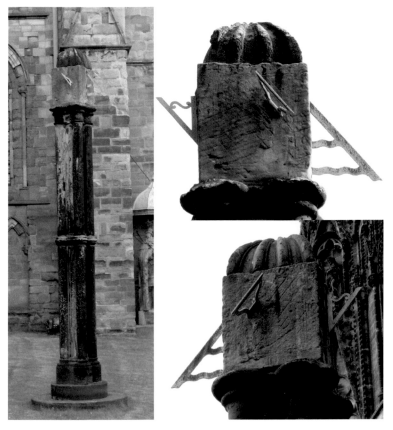

The sundial outside the cathedral. The upper right is the west face and the lower right image is the east face.

This practice came to an end in 1797 when the government reissued one and two penny coins. Amongst those issued in Lichfield were that from Lemmonsly (Leamonsley).

Richard Greene, Lichfield's first museum curator, died on 4 June 1793. Greene spent his entire life in Lichfield. He held several trades: apothecary, surgeon, and printer. An avid collector, he opened up his house on Market Street as a museum, for the public to view his

Above: The Leamonsley Mill token, worth twopence each. Shopkeepers receiving these tokens could trade 120 of them back to John Henrickson, the owner of Leamonsley Mill, for one pound. The obverse depicts the cotton mill, JOHN HENRICKSON LEMMONSLY MILL NEAR LICHFIELD. The reverse depicts the city coat of arms, ONE POUND NOTE FOR 120 TOKENS. (Copyright: Lichfield District Council)

Left: Portrait of Richard Greene, by E. Stringer before 1798. (Copyright: The British Library)

View of Mr Greene's museum at Lichfield, by Thomas Cook in either 1788 or 1798. (Copyright: The British Library)

collections. A catalogue was produced in 1773 which shows that the collection included archaeological finds, armour, coins, specimens of natural history as well as items from the South Seas, and a musical clock that played Handel's music. Johnson and his friend James Boswell visited the museum in 1776.

Greene's skills as an antiquarian came in use when a medieval gravestone was uncovered when work was carried out near the cathedral's north door. The gravestone was finely decorated with an ornate cross with foliate ends and a falchion (short sword). When they lifted it up they discovered a stone coffin containing a skull, leg and thigh bones and some vertebrae. The rest of the bones had crumbled into dust. Greene looked at the bones and determined that although a weapon was carved on the outside, this did not prove that a warrior was buried inside. Later in 1800, his grandson, Richard Wright, issued a provincial token commemorating his grandfather and his founding of the first Lichfield Museum.

Built between 1794 and 1797, Lichfield Canal covered just over 7 miles and was historically a part of the Wyrley and Essington Canal. The canal ran from Ogley Junction on the northern Birmingham Canal Navigations to Huddlesford Junction on the Coventry Canal. The right

Left: The reused gravestone at the north door, overlaid with the illustration done at the time of excavation by Richard Greene. (Copyright: British Library & Teresa Gilmore)

Below: The provincial copper penny token issued commemorating Richard Greene, issued in 1800 by his grandson, Richard Wright. Obverse, portrait of Richard Greene facing left, RICHARD GREENE COLLECTOR OF THE LITCHFIELD MUSEUM DIED JUNE 4 1793 AGED 77. Reverse, the west porch of the cathedral, WEST PORCH OF LICHFIELD CATHEDRAL 1800. Rim (not visible in the photo) is the inscription: PENNY TOKEN PAYABLE BY RICHARD WRIGHT LICHFIELD. (Copyright: Lichfield District Council)

to navigation was extinguished by Act of Parliament in 1954 and much of the canal was subsequently infilled. The canal ran through the centre of the site on a northwest–southeast alignment, passing under Shortbutts Lane Bridge immediately to the north. A wharf was located nearby, and was christened 'Gallows Wharf', as the Gallows were located nearby.

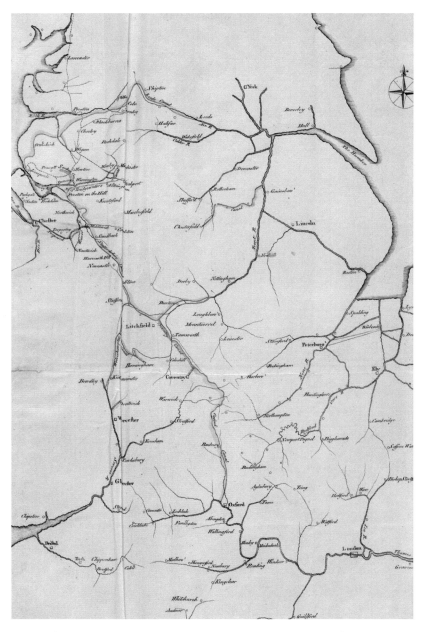

Extract from a Plan of the Canals authorised to be made in different parts of England, showing the communication they will open between the Principal Navigable Rivers and Ports of the Kingdom, drawn around 1790. (Copyright: The British Library)

8

Mecha'nical Mecha'nick

Mecha'nical Mecha'nick adj. [mechanicus, Lat. mechanique, French; from μηχανὴ.]
2. Constructed by the laws of mechanicks.
The main business of natural philosophy is to argue from phenomena without feigning hypotheses, and to deduce causes from effects till we come to the very first cause, which certainly is not mechanical; and not only to unfold the mechanism of the world, but chiefly to resolve these, and such like questions.
Newton's Opticks.

Lichfield's heyday as a coaching centre came to an end as canals and then locomotives were invented. The reduction of coach travel was significant as initially no canals or railway lines ran close to the city. After the Wryley and Essington Canal, the Trent Valley Railway provided links to the wider transport network, and trade and economy improved.

The city was run by the Corporation of Lichfield with help from the Conduit Land Trust. Homes were upgraded with the addition of clean running water and, towards the end of the century, electricity.

The last use of the Gallows was in 1810, for the execution of three men: John Neve, William Weightman and James Jackson. Neve ran a drapery business in Birmingham which closed due to hard times. Being out of work, he got a job at Weightman's drapery business, in Birmingham, and was later joined by Jackson, formerly a Cheshire miner. Financial difficulties caused them to draw up counterfeit bills of exchange and banknotes. Weightman was caught passing on a forged £1 Bank of England note, and Neve a £5 note. Jackson was committed as being involved. The Lichfield Assizes trial lasted several days, with the result that all three were convicted of forgery and sentenced to death. On 1 June, they were loaded into a wagon and taken down to the Gallows at Gallows Wharf. A large crowd of people came out to witness it. Afterwards all three were buried in St Michael's cemetery, with a small tombstone. It was originally inscribed with 'N.W.J. HANGED LICHFIELD June 1810'. However, more recently the word 'HANGED' has been removed in respect for their families.

Henry Paget, 1st Marquess of Anglesey and landowner of Longdon Manor, rode through Lichfield as part of a triumphal procession celebrating the victory at Waterloo. He fought not only during the Napoleonic Wars (1808–14), but also in the French Revolutionary Wars (1792–1802). He enrolled as lieutenant-colonel, and then rose to cavalry commander in the Peninsular War (1807–14). He led the cavalry charge as cavalry commander at Waterloo and helped win the battle. Towards the end, a cannonball hit his right leg and he required a field amputation. The amputated leg ended up in a small garden shrine of the house where the amputation had happened. Afterwards, Paget was known as 'One-leg Paget' or 'Old One-Leg'. He was later buried at Lichfield Cathedral on 5 May 1854.

The *Lichfield Mercury* was first published on 7 July 1815, with the main story being about the Battle of Waterloo. The *Mercury* stayed in circulation for over 200 years until the coronavirus pandemic in 2020 caused publication to cease.

While the Duke of Anglesey was off fighting in the war, seventy-four prisoners of war were given temporary quarters. Some were housed in Bird Street, where centuries later as the Old Bolton Warehouse Company shop was being demolished, a circular room was found hidden above a ceiling. This room had been decorated with several shell mosaics, including a depiction of the west front of the cathedral. Other prisoners, like De Giborne, were housed at 'Frenchman's Cottage' on Cherry Orchard. Another one, Major St Croix, gave French lessons to local children and another, Cato, settled in the city and his children ended up running the Three Crowns pub on Breadmarket Street.

The 'Sleeping Children' memorial in the south choir of the cathedral was donated by Ellen-Jane Robinson in 1817 in memory of her two daughters, Ellen-Jane and Marianne. Ellen Robinson was married to the Reverend William Robinson, prebendary of the cathedral. Tuberculosis claimed his life in 1812, and sadly within two years, Ellen would lose both her daughters as well. The eldest, Ellen-Jane, died following bad burns caused by her nightdress catching fire, and the youngest, Marianne, from tuberculosis like her father. In her grief, Ellen commissioned Sir Francis Chantrey to create a memorial to depict them at rest, sleeping together as they used to do in life. The finished memorial was exhibited at the Royal Academy Exhibition in 1816 where it was greatly received. Ellen-Jane Robinson remarried in 1835 to Richard Hinckley. Her husband donated land and she donated money to build a new church, Christ Church, and associated school in 1847.

The races carried on in popularity, with a new brick grandstand being built at Whittington. It went out of use as the grandstand in 1875, when the racecourse was sold off to make space for the military barracks being erected on Whittington Heath.

A wooden box with marquetry decoration manufactured by the French prisoners of war housed locally between 1808 and 1814. Prisoners of war produced handicrafts and decorative objects to trade with residents. None of the shell mosaics have survived. (Copyright: Lichfield District Council)

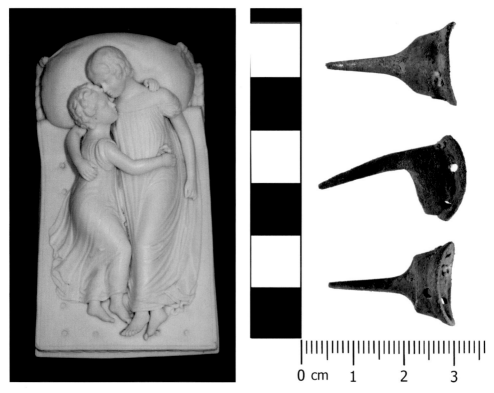

Above left: The Parian ware sculpture of the 'Sleeping Children' as commissioned by Ellen-Jane Robinson. It was manufactured by Minton around 1851. The original marble sculpture is in the southeast corner of the cathedral by the lady chapel. (Copyright: Lichfield District Council)

Above right: A copper alloy cock spur, found in Staffordshire. The spur would have been secured around the spurs on the cockerel's legs to enhance them. (Copyright: The Portable Antiquities Scheme)

Cock fighting was banned in 1835, sending it 'underground' for those who wished to continue the pastime. In 1607 George Wilson wrote the earliest book all about the sport, *In commendation of Cocks and Cock fighting*. He stated that it was the princeliest of sports, prior to horse racing. Both the Swan Inn (Bird Street) and the Blue Boar (Church Street) would regularly stage cock fights in specially created cock pits. Breeding fighting cocks was a skilful business as the cocks needed both stamina and strength. Breeders debated what the best diet was to create the best cock, whether custard and eggs were better than wheat, oatmeal and hot wine. To help the cock fight better, 'cockspurs' were attached to the cockerel's leg by a leather strap. These involved a metal spike and collar. The collar sat around the natural spur on the back of the leg, and the spike pointed outwards. The last recorded cock fight was in 1877.

In 1850, the Public Libraries Act had been passed, enabling money for local authorities to build public libraries. The Corporation of Lichfield was the second local authority to make use of the funds (Manchester were the first). With help from Chancellor James Law,

The Free Library and Museum building in the Museum Gardens, Beacon Park. It is no longer a library and museum but a registry office.

they commissioned the Free Library and Museum building to be built. The architects chosen were Messers Bidlake and Lovatt of Wolverhampton, with an original Italianate design. Buttresses were added later as the infilling of the Bishop's Pool, creating the Museum Gardens to the south, resulted in unstable ground. The library opened to the public in April 1859. The layout had the library and reading room on the ground floor and the museum on the first floor. The basement held exhibition rooms for sculpture and the residence for the keeper. The building is now used as the registry office.

The sailor statue on the exterior was a gift from local stonemason Robert Bridgeman. His cap band originally read 'H.M.S. Powerful'. He was originally carved for a war memorial up in York, but he never ended up there and was placed on the outside of the Free Library. The fountain in the centre of the park was a generous donation by Chancellor Law.

The rest of Beacon Park has two people to thank: Patience Swinfen-Broun and her stepson Michael Swinfen-Broun. Michael was a former soldier of the South Staffordshire Regiment and local Sheriff. He donated 12 acres from the land of Beacon Hall to the people of Lichfield for use as a park. His stepmother, Patience, received notoriety earlier in her life for a lawsuit challenging the right of inheritance.

Messers Palmer and Greene operated as the principal local bank, allied with Messers Smith, Payne and Smith in London. They would issue provincial banknotes, promises which the bearer could return to the bank to exchange for hard currency. One of the partners, James Palmer, died in 1850 and his partner, Richard Greene (the grandson of Richard Greene who opened the first museum), discovered that there was a debt of £60,000 to the bank which Palmer's estate did not cover. Initially Greene continued operating the bank but following a house sale, their partner bank, Messers Smith, Payne and Smith, withdrew

The fountain donated by Chancellor Law to the City of Lichfield in Beacon Park.

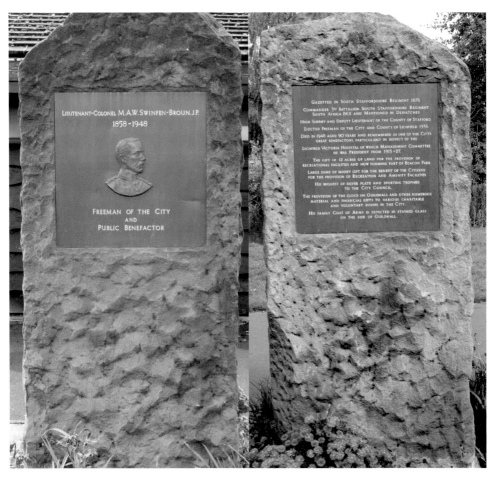

Front and back views of the Swinfen-Broun monument in Beacon Park. The front reads: 'Lieutenant-Colonel M.A.W. Swinfen-Broun J.P. 1858-1948. Freeman of the City and Public Benefactor'. The back provides more information of Lieutenant-Colonel Swinfen-Broun's life and what he did for the city of Lichfield.

their credit facilities. This caused Greene to close the bank on 31 December 1855 and declare bankruptcy. During the bankruptcy investigation when the bank ledgers were examined, the clerk, William Lawton, owned up to what he had been doing for the previous six years, which was embezzling funds. Instead of withdrawing and destroying worn banknotes, Lawton had been pocketing them and issuing new ones. He had been stealing the notes to help a friend finance an inheritance case that had been dragging on for years, in the hope that when it came to a successful conclusion, Lawton would be repaid. He wasn't. Lawton was found guilty and sentenced to four years of penal service in Lichfield Gaol.

During Greene's bankruptcy hearing, he was found liable for £180,000. His assets, including his property, Stowe House and the attached farm, only amounted to £121,000. The house and contents were auctioned off. He and his family went from being respected members of society to paupers overnight.

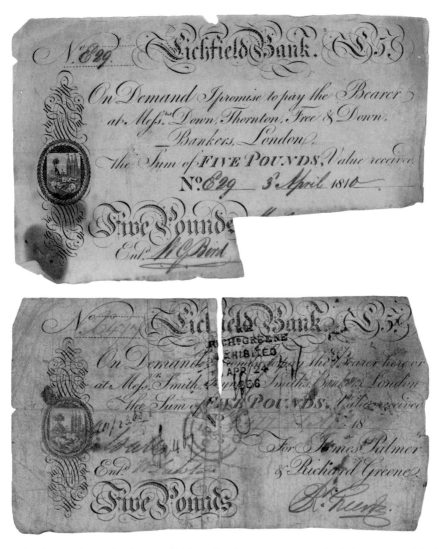

Two £5 banknotes issued by the Lichfield Bank. The upper one has had the bottom right-hand corner cut away, which happened either when the note was cashed in or when the Lichfield Bank was wound up. The lower one was exhibited as a piece of evidence at Richard Greene's bankruptcy hearing. (Copyright: Lichfield District Council)

The Minors School for boys continued until 1876, when it merged with the grammar school and four scholarship places were created for the 'minors' boys. The building was partially demolished in 1914 for the widening of the road junction. In 1849, a new premise was secured for the King Edward VI (grammar) school on the St John Street site (now occupied by Lichfield District Council). In 1903 the school moved to its present location on Borrowcop and in 1971 merged with the King's Hill school to form a mixed comprehensive.

Brewing became the biggest industry in town, rivalling neighbours Burton-upon-Trent. It started with three brewers and nineteen maltsters in the city, mostly situated in

Greenhill, Tamworth Street and the Lombard Street area in 1834. John and Arthur Griffith, originally wine merchants, opened a brewery in Beacon Street, with a malthouse in 1848. Later in 1869, Griffith's firm merged with John, Henry and William Gilbert in Tamworth Street to form the Lichfield Brewery Company. By 1873, they had opened a new brewery, close to the railway on Upper St John Street. A large malthouse was built on the opposite side of the road. The brewery company was bought by Burton brewers James Allsop and Sons and brewing continued until 1931.

The former medieval ponds had silted up and were nicknamed 'The Moggs'. Local women would wash their clothes in them. Tanning and dyeing trades would empty their finished liquid into the pools. There were calls to fill in all the pools, but outbreaks of cholera in the Black Country in 1832 and 1849 saved them. Both Minster Pool and Stowe Pool were cleaned and emptied out to turn them into reservoirs so that the clean water could be pumped from Sandfields pumping station, built in 1858. The Sandfields pumping station is located on the south side of Lichfield and was improved with a Cornish pumping engine in 1873. The dredged silt from Minster Pool and Stowe Pool filled up the Bishops' Pool and created the ornamental garden, the Museums Gardens at the entrance to Beacon Park.

In January 1873, a fire at the premises of a Lichfield clock and watch maker on Breadmarket Street had terrible consequences. Three generations of that family lost their lives. None of the bystanders attempted a rescue as they thought the family had escaped.

The Lichfield Brewery Company and Malthouse buildings on Upper St John Street.

The Engine House at Sandfields Pumping Station. It was built for the South Staffordshire Waterworks Company in 1872–73 as an extension for the now demolished pumping station of 1858. The building is preserved by the Lichfield Waterworks Trust.

Their bodies were retrieved and given the last rites by a Catholic priest. They were laid to rest in St Michael's cemetery. The council then took over firefighting responsibilities, bought a fire engine and established a fire station on Sandford Street.

The Guildhall was rebuilt, with a stained-glass window donated from the cathedral placed centrally, with busts of George V and his wife Mary on either side. This building operated as a magistrate's court, police station, gaol, theatre and even a fire station. The doors on the ground level relate to its functioning as fire station as a hand-pulled fire engine was stationed there. When a fire broke out, the fire engine was fetched and taken to the blaze.

The gaol cells are located on the ground floor, at the rear of the Guildhall. The current gaol cells were part of a larger gaol and police station complex totalling fourteen cells, six day rooms and five open-air yards. The four cells that survive provide a glimpse into life and conditions in prison cells during the nineteenth century. Prisoners earnt their keep whilst being held, carrying out work such as grinding corn and making pins. Bedding, bibles, and prayer books were supplied for the prisoners, along with clothing if necessary. But prisoners had to make their own meals, either by food supplied by the city, or by food from their family. The gaol went out of use in 1848 as changes in the law meant that these

cells were no longer suitable. All prisoners were then transported to Stafford after their trials. The cells saw occasional use as a lock-up for drunkards.

At the cathedral, Sydney Smirke took over after Wyatt and his deputy, Joseph Potter. He reinforced the south side of the nave, cleaned plaster off sculptural details and attempted to restore some medieval aspects. When Sir George Gilbert Scott senior arrived, Smirke resigned. Scott restored the choir, choir screen, opened the interior and removed in some places work done by Wyatt, Potter and Smirke. His son, John Oldrid Scott, restored the west front, employing local stonemason Robert Bridgeman & Son to recreate most of the statues. Several of the statues were carved by women. Queen Victoria was sculpted by her daughter, Princess Louise, and Chad, Christ and the Apostles were carved by Mary Grant.

The Lichfield to Birmingham Horse Drawn Coach service continued to operate until the 1870s, when the railways took over. The coach would leave the George Hotel at 8 a.m. and arrive at its destination, the Swan Hotel in Birmingham, at 4 p.m. The South Staffordshire Railway was approved in 1847 to operate a service from Dudley to Burton-upon-Trent, through Walsall and Lichfield. Ownership of the line transferred over to the London and North Western Railway in 1867.

An industrial and loan exhibition was held in Lichfield in 1874, one of a series of events that took place around the country to celebrate British industrial prowess following the Great Exhibition in London in 1851. It championed new technologies and manufacturing techniques. Medallions were produced commemorating the exhibition.

The market place hosted a well-attended meeting of the Women's Social and Political Union (Suffragettes) in 1913. It was chaired by Miss C. Reid of London who championed the role of women in the government and supported militant tactics to gain the vote for women. Five years later, women over the age of thirty were allowed to vote. Eighteen months after she gained the right to vote, Daisy Stuart Shaw became the first female

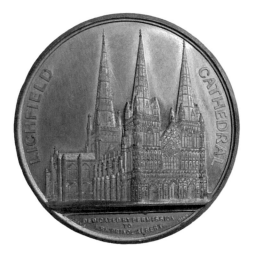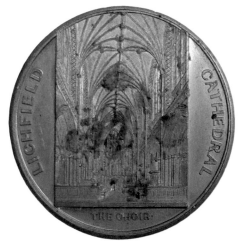

A commemorative medallion celebrating the restoration of the choir in the cathedral by Sir Gilbert Scott, issued in 1849. Obverse, west front of the cathedral and LICHFIELD CATHEDRAL. Below DEDICATED BY PERMISSION TO H.R.H. PRINCE ALBERT. Reverse, interior of the choir and LICHFIELD CATHEDRAL THE CHOIR. (Copyright: Lichfield District Council)

The Lichfield to Birmingham Omnibus token. This token entitled the bearer to catch the horse-drawn service from the George Hotel on Bird Street, Lichfield, at 8 a.m. They would arrive at their destination, the Swan Hotel in Birmingham, at 4 p.m. (Copyright: Lichfield District Council)

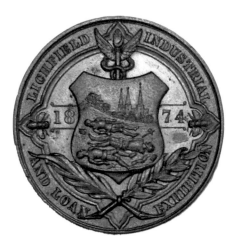

This medallion was issued to celebrate the Industrial and Loan Exhibition in Lichfield in 1874. It was produced by J. Moore of Birmingham. The obverse depicts the coat of arms of the city, with a snake entwined Caduceus to represent Commerce; two bees are either side to represent industry. The obverse legend reads: LICHFIELD INDUSTRIAL AND LOAN EXHIBITION 1874. The reverse depicts Industry as a female figure, holding laurel wreaths and surrounded by industrial and chemical equipment. The cathedral is in the background. (Copyright: Lichfield District Council)

councillor for the South Ward. She continued to hold her position for twenty years, becoming the first female mayor in 1927.

The Mayor of Lichfield, Henry G. Hall, issued a First World War peace medal in 1919. This medal shows the change in the city's coat of arms. The Christian martyrs are replaced by a chequerboard of squares alternating between ermines and the red chevron associated

with the Stafford family. The Garden of Remembrance was opened on 20 October 1920 as an Act of Remembrance following the First World War. Within its boundaries is the war memorial carved by Robert Bridgeman & Sons and commemorates local casualties from the First and Second World Wars.

This medal was issued by Henry G. Hall, Mayor of Lichfield in 1919, to commemorate the end of First World War. The obverse depicts a soldier kneeling and presenting a sword to a Winged Victory holding a dove. Peace is stood next to Victory, holding an olive branch All are beneath Heavenly rays. The inscription simply reads PEACE. The reverse depicts the new coat of arms of the city of Lichfield inside a floral garland. Above the shield, the banner reads: TO COMMEMORATE THE VICTORIOUS CONCLUSION OF THE GREAT WAR 1919. The border has the inscription: LICHFIELD HENRY G. HALL MAYOR. (Copyright: Lichfield District Council)

The war memorial in the Garden of Remembrance. The war memorial was carved by stonemasons Robert Bridgeman, who had their stone yard on Dam Street. The top three panels are dedicated to soldiers in the First World War and the lower three panels are for those soldiers of the Second World War.

Appendix

Bishops of Lichfield and Coventry

Bishops of Mercia

Ruler	Date	Name
	? – after 655	Diuma
	Unclear	Ceollach
	c. 658 – c. 662	Trumhere
	c. 662 – c. 667	Jaruman

Bishops of Mercia and Lindsey People (based at Lichfield)

Ruler	Date	Name	Comments
	669–672	Ceadda (Chad)	Saint Chad. Died in office

Bishops of Lichfield

Ruler	Date	Name	Comments
	672 – c. 675	Wynfrith	
	c. 676 – before 692	Seaxwulf	Saint Sexwulf
	691 – between 716–727	Headda	
	Before 731–737	Ealdwine	
	737 – between 749–767	Hwita	
Offa of Mercia (757–796)	Before 757–765	Hemele	
	c. 765 – c. 769	Cuthfrith	Died in office
	c. 769 – between 777–779	Berhthun	Died in office
	779–787	Hygebeorht	Created Archbishop in 787

Archbishop of Lichfield

Ruler	Date	Name	Comments
Offa of Mercia (757–796) Coenwulf of Mercia (796–821)	787–799	Hygebeorht	Archbishop of Lichfield after 787 to 801

Bishops of Lichfield

Ruler	Date	Name	Comments
Coenwulf of Mercia (796–821)	Between 799–801 to between 814–816	Ealdwulf	Title of Archbishop laid aside
Coenwulf of Mercia (796–821	Between 814–816 to between 817–818	Herewine	
Coelwulf I of Mercia (821–823) Beornwulf of Mercia (823–825) Ludica of Mercia (825–827) Wiglaf of Mercia (827–840)	818–830	Aethelweard	
Wiglaf of Mercia (827–840)	830 – between 830–836	Hunbeorht	
Wiglaf of Mercia (827–840) Berhtwulf of Mercia (840–852)	Between 830–836 to between 841–845	Cynefrith	Saint Cumbert
Berhtwulf of Mercia (840–852) Burgred of Mercia (852–874)	Between 843–845 to between 857–862	Tunbeorht	
Burgred of Mercia (852–874)	Between 857–862 to between 866–869	Wulfsige	

Ruler	Date	Name	Comments
Burgred of Mercia (852–874	Between 866–869 to between 875–883	Eadbeorht	
Ceolwulf II of Mercia (874–877)	Between 875–883 to between 889–900	Wulfred	
	Between 889–900 to between 909–915	Wigmund	
Aethelstan (924–939)	Between 903–915 to 935–941	Aelfwine	
Edmund I (939–946)	Between 935–941 to between 946–949	Aelfgar	
Eadred (946–955) Eadwig (955–959)	Between 946–949 to between 963–964	Cynesige	
Edgar the Peaceful (959–975)	Between 963–964 to 975	Wynsige	
Edward the Martyr (975–978) Aethelred the Unready (978–1013)	975 to between 1002–1004	Aelfheah	
Sweyn Forkbeard (1013–1014) Aethelred the Unready (1014–1016)	Between 1002–1004 to after 1017	Godwine	
Edmund Ironside (1016) Canute (1016–1035)	After 1017 to between 1026–1027	Leofgar	
Harold Harefoot (1035–1040)	c. 1027 to 1039	Beorhtmaer	
Harthacnut (1040–1042) Edward the Confessor (1043–1066) Harold Godwinson (1066)	1039 to 1053	Wulfsige	
William the Conqueror (1066–1087)	1053 to 1067	Leofwine	First Abbot of Coventry 1043
	1067 to 1075	Peter	Council of London (1075), removed see to Chester

Bishops of Chester

Ruler	Date	Name	Comments
William the Conqueror	1075 to 1085	Peter	Transferred his see to Chester 1073
William II (1087–1100) Henry I (1100–1135)	1086 to 1102	Robert de Limesey	Transferred his see to Coventry 1102

Bishops of Coventry

Ruler	Date	Name	Comments
Henry I	1102 to 1117	Robert de Limesey	Died in office.
	1117 to 1121		vacant for four years
	1121 to 1126	Robert Peche	Chaplain to Henry I. Died in office
	1126 to 1129		Vacant for two years
Henry I Stephen (1135 to 1154)	1129 to 1148	Roger de Clinton	Also called Bishop of Lichfield & Bishop of Coventry & Lichfield The Anarchy – civil war between Stephen and Matilda between 1138 and 1153
Henry II (1154 to 1189)	1149 to 1159	Walter Durdent	Charter to hold a regular market granted by King Stephen.
	1161 to 1182	Richard Peche	
	1183 to 1184	Gerard La Pucelle	
	1184 to 1188		Vacant
Richard I (1189 to 1199)	1188 to 1198	Hugh Nonant	Lichfield mint in operation in the cathedral close
John I (1199 to 1216)	1198 to 1208	Geoffrey Muschamp	
	1208 to 1215		Vacant due to an intervention by Pope Innocent III against King John's realms
Henry III (1216 to 1272)	1215 to 1223	William de Cornhill	
	1224 to 1228	Alexander Stavensby	Became Bishop of Coventry and Lichfield

Bishops of Coventry and Lichfield

Ruler	Date	Name	Comments
Henry III	1228–1238	Alexander Stavensby	
	1239	William de Raley	Was elected Bishop of C&L and also Norwich. Accepted Norwich
	1239	Nicholas Farnham	Elected by the Chapter of Coventry but didn't take office. Eventually Bishop of Durham
	1239	William de Mancetter	Dean of Lichfield. Elected but didn't take offer. Buried in the Cathedral
	1239–1241	Hugh Pateshull	Lord Treasurer. Accepted by Henry III's request. Died in office
	1241	Richard le Gras	Abbot of Evesham. Elected but declined or died before taking office
	1241–1245		vacant
	1243	Robert de Monte Pessulano	Elected but turned down appointed. Henry III objected.
	1245–1256	Roger Weseham	Appointed by Pope Innocent IV
Edward I (1272–1307)	1258–1295	Roger Longespec	
Edward II (1307–1327)	1296–1321	Walter Langton	Was Lord Treasurer and Lord Chancellor in the royal court. Fortified the Cathedral close.
Edward III (1327–1377)	1322–1358	Roger Northburgh	Held the roles of Lord Keeper and Lord Treasurer in the royal court. Edward III visits in 1347 to celebrate the victory of the Battle of Crecy.
Richard II (1377–1399)	1360–1385	Robert Stretton	
	1386	Walter Skirlaw	
	1386–1398	Richard le Scrope	
Henry IV (1399–1413)	1398–1414	John Burghill	
Henry V (1413–1422)	1415–1419	John Catterick	

Ruler	Date	Name	Comments
Henry VI (1422–1461)	1420–1447	William Heyworth	
Edward IV (1461–1470)	1447–1452	William Booth	
	1452	Nicholas Close	Chancellor of Cambridge
	1453–1459	Reginald Boulers	The Wars of Roses (1455–1485)
Henry VI (1470–1471) Edward IV (1471–1483) Edward V (1483) Richard III (1483–1485) Henry VII (1485–1509)	1459–1490	John Hales	
Henry VII	1493–1490	William Smyth	
	1496–1502	John Arundel	
Henry VIII (1509–1547)	1503–1531	Geoffrey Blythe	
	1534–1539	Rowland Lee	Chancellor & Prebendary of Lichfield. Lord President of Wales. Title changed when Coventry Cathedral was dissolved.

Bishops of Lichfield and Coventry

Ruler	Date	Bishop	Comments
Henry VIII (1509–1547)	1539–1543	Rowland Lee	Previously Bishop of Coventry and Lichfield, prior to the Dissolution of the Monasteries
Edward VI (1547–1553) Mary I (1553–1558)	1543–1554	Richard Sampson	Lord President of Wales
Elizabeth I (1558–1603)	1554–1559	Ralph Bayne	Last Roman Catholic Bishop. Deprived of office and died shortly afterwards
	1560–1579	Thomas Bentham	
James I (1603–1625)	1580–1609	William Overton	
	1609–1610	George Abbot	
	1610–1614	Richard Neile	
	1614–1618	John Overall	

Ruler	Date	Bishop	Comments
Charles I (1625–1649)	1619–1632	Thomas Morton	
	1632–1643	Robert Wright	English Civil War (1642–1649)
	1644–1646	Accepted Frewen	Deprived of the see when the English episcopy was abolished by Parliament on 9th October 1646
The Commonwealth Oliver Cromwell (1653–1658) Richard Cromwell (1658–1659)	1646–1660		The see was abolished during the Commonwealth and the Protectorate.
Charles II (1660–1685)	1660	Accepted Frewen	Restored to the see. Then moved to York.
	1661–1670	John Hackett	Responsible for the restoration of most of the Cathedral
James II (1685–1688) William III & Mary II (1688–1694)	1671–1692	Thomas Wood	
William III (1694–1702)	1692–1699	William Lloyd	
Anne (1702–1707) George I (1714–1727)	1699–1717	John Hough	
	1717–1730	Edward Chandler	
George II (1727–1760)	1731–1749	Richard Smallbrooke	
George III (1760–1820)	1750–1768	Frederick Cornwallis	
	1768–1771	John Egerton	
	1771–1774	Brownlow North	
	1775–1781	Richard Hurd	
George IV (1820–1830)	1781–1824	James Cornwallis	Earl Cornwallis after 1823. Nephew of Frederick Cornwallis.
William IV (1830–1837)	1824–1836	Henry Ryder	
Victoria (1837–1901)	1836–1837	Samuel Butler	Became Bishop of Lichfield when Coventry was transferred to the Worcester diocese

Bishops of Lichfield

Ruler	Date	Bishop	Comments
Victoria (1837–1901)	1837–1839	Samuel Butler	Previously Bishop of Lichfield and Coventry.
	1840–1843	James Bowstead	
	1843–1867	John Lonsdale	
	1868–1878	George Selwyn	Transferred from New Zealand. Tomb in the Lady Chapel
	1878–1891	William Maclagan	
Edward VII (1901–1910)	1891–1913	Augustus Legge	
George V (1910–1936) Edward VIII (1936)	1913–1937	John Kempthorne	World War I (1914–1918)
George VI (1936–1952)	1937–1953	Edward Woods	World War II (1942–1945)
Elizabeth II (1952–2022)	1953–1974	Stretton Reeve	
	1975–1984	Kenneth Skelton	
	1984–2003	Keith Sutton	
	2003–2015	Jonathan Gledhill	
	2015–2016	Clive Gregory	Acting Bishop
	2016–present	Michael Ipgrave	

Further Reading

Clayton, H., *Loyal and Ancient City. The Civil War in Lichfield* (Derby: J. M. Tatler & Sons, 1987)

Clayton, H., *Coaching City* (Derby: J. M. Tatler & Sons, 1971)

Clayton, H., *Cathedral City: A Look at Victorian Lichfield* (Rugeley: Benhill Press Lt, 1981)

Coley, N., *The Lichfield Book of Days* (Stroud: The History Press, 2014)

Coley, N., *Secret Lichfield* (Stroud: Amberley Publishing, 2018)

Gilmore, T., *50 Finds from Staffordshire* (Stroud: Amberley Publishing, 2018)

Greenslade, M. W. (ed), *A History of the County of Stafford: Volume 14* (Lichfield: Victoria County History, London, 1990)

Musgrove Knibb, J., *Lichfield in 50 Buildings* (Stroud: Amberley Publishing, 2016)

Oates, J., *A–Z of Lichfield* (Stroud: Amberley Publishing, 2019)

Shaw, J., *Street Names of Lichfield* (Lichfield: George Lane Publishing, 2003)

Upton, C., *A History of Lichfield* (Stroud: Phillimore & Co., 2001)